Edward Lucie-Smith

TOULOUSE-
LAUTREC

PHAIDON

The author and publishers would like to thank all those museum authorities and private owners who have kindly allowed works in their possession to be reproduced.

Phaidon Press Limited
Littlegate House, St Ebbe's Street, Oxford

Published in the United States of America by E.P. Dutton, New York

First published 1977

© 1977 by Phaidon Press Ltd

ISBN 0 7148 1802 X

Library of Congress Catalog Card Number: 77-80135

Printed in Great Britain

TOULOUSE-LAUTREC

A few artists have found a place in the popular consciousness, not so much because of their art, but because of the legend created by their lives. Van Gogh and Gauguin are two of these, and Henri de Toulouse-Lautrec is a third. In this sense they outrank contemporaries who were equally or perhaps even more gifted, among them Degas, Monet and Cézanne. Indeed, while the latter three hold a more central position in European painting, it is the former three who have been largely responsible for creating the current popular image of the artist. There is no major film about the life of Degas, while John Houston's 1952 film-biography of Lautrec, *Moulin Rouge*, has been seen by hundreds of thousands of people, who no doubt took away from it an ineffaceable – if overdrawn – idea of the artist and the world he inhabited.

The life stories of Van Gogh and Gauguin follow a romantic pattern, and are clearly ready to serve as archetypes of the artist's relationship to society. Van Gogh ended in madness and suicide; Gauguin deliberately exiled himself from European civilization. Their most typical paintings are statements about certain ideas and needs – in Van Gogh's case about the paramountcy of feeling, and about the duty to experience every moment as intensely as possible, whatever the consequences; and in Gauguin's about the thirst for the primitive, which has since exercised so great an influence upon twentieth-century artists. Lautrec's position is different. His life story is hardly one with which the ordinary individual can identify. Though it is a tragedy, it is one without universal application. The secret of his appeal must be looked for elsewhere.

Lautrec was born on 24 November 1869, in Albi. His full name was Henri-Marie-Raymond de Toulouse-Lautrec, and he belonged to one of the most ancient families in France, that of the medieval Counts of Toulouse. His parents were cousins, and were ill-suited to one another. His mother, Countess Adèle, pious, intelligent and virtuous, would have liked a peaceful, retired kind of existence. Her husband, Count Alphonse, was extrovert and eccentric, the prisoner of the impulse of the moment. He enjoyed dressing up, and would make his appearance as a cowboy or a Circassian. On one occasion he sat down at the family lunch table wearing a Highlander's plaid and a dancer's tutu. His passions in life were hunting and hawking, and he was notoriously unfaithful to his wife. Their marriage soon ceased to be one in anything but name.

The Lautrec family had artistic impulses, but of a strictly amateur kind. Henri's father and uncles were competent draughtsmen. Count Alphonse did a little modelling too, making statuettes of horses and hounds. It is unlikely that Lautrec himself would have become a professional artist but for the cruelty of nature. He had always been a frail child, and in May 1878 he had a serious accident, fracturing his left femur. He had already been studying in the studio of the well-known sporting artist René Princeteau, who was a friend of his father, and he spent his convalescence drawing and painting. But the bone was slow to mend. Fifteen months after the accident he was at last well enough to take strolls in the countryside accompanied by his mother. Then in August 1879 he had another accident, this time breaking his other leg. After these two fractures, Lautrec's legs stopped growing, although his torso matured normally. As his adolescence progressed he became a

grotesque dwarf, with a thick nose, swollen, puffy lips, a retreating chin and a strange waddling walk. It was clear that he would never become a vigorous sportsman like his father and grandfather.

Lautrec had been becoming more and more absorbed in his artistic activities, and now Princeteau helped him persuade his family (who were not wholly in love with the thought) that he should train as a professional painter. In March 1882 he entered the studio of Léon Bonnat, a well-known academic portraitist who was also celebrated for his prowess as a teacher. Here he gained a thorough grounding in those techniques of painting and draughtsmanship which had descended to Bonnat from David and Ingres, the two great neo-classical masters of the beginning of the century. It was upon their methods that all artistic instruction was still based. Despite his odd appearance Lautrec soon became popular with his fellow students, who loved him for his cheerfulness and appreciated the fact that he was free with his money. He discovered the pleasures of the Parisian cafés and café-concerts, and with them the pleasure of drinking. When Bonnat decided to close his studio, Lautrec, now thoroughly established as a boon companion, moved with the rest of his pupils to the atelier of another well-known academician, Fernand Cormon. This was situated at 10 rue Constance, Montmartre.

The Montmartre of the early 1880s, when Lautrec first knew it, was just beginning to enter into its period of greatest glory. The first cabarets had opened, there was a rustic dance-hall called the Moulin de la Galette, and there was the Chat Noir, a rendezvous for artists run by a man named Rodolphe Salis. Lautrec, who had been living with his mother in another district of Paris, now decided to share an apartment with a friend in Montmartre itself. This made all its nighttime pleasures accessible to him.

Inevitably the Chat Noir was one of the places he frequented. But he found Salis pretentious, and came to prefer the Elysée-Montmartre, a nearby dance-hall which had become famous for its revival of the *chahut* (which we call the can can) under the coy title of 'the naturalist quadrille'. Lautrec was immensely attracted by the frenetic energy of the dancers, and he found an equal attraction in the types who frequented the place. When Salis sold the Chat Noir, and it was re-opened by the singer Aristide Bruant as the Mirliton, he started to discover a renewed attraction there as well. He admired Bruant's sarcastic humour, his ability to express the miseries as well as the joys of those who lived on the fringes of society, and the rough way in which he treated prosperous customers come in search of a little low-life. Gradually, he started to abandon the subjects prescribed by convention, and to depict instead what really interested him.

His fascination for the stage probably derived from his own peculiarly alienated circumstances. The notion of disguise appealed to him – he loved dressing up almost as much as his father did, and a number of strange photographs (some showing the painter in female costume) survive to prove it. The effects produced on stage – by dress and lighting – were part of the whole process of alienation, which removed the performer into another sphere, and enabled him or her to find an intensity otherwise unavailable.

As his interest in the cabaret and theatre developed, a number of other important events had taken place. Lautrec had encountered the young painter Emile Bernard (Plate 2), a fellow-student in Cormon's studio, and had imbibed from him ideas which came from the Impressionists. A little later, once again *chez* Cormon, he met Vincent van Gogh. Bruant, with whom he had become friendly, hung some of his pictures at the Mirliton, and asked him, in addition, to do some designs for a magazine he was producing. Other

signs of recognition followed. In 1888, Lautrec was asked to exhibit with 'Les Vingt' in Brussels – a great honour since it was probably the most advanced exhibition-society in Europe. This was also the year, according to leading authorities, in which he contracted syphilis from a girl called Rosa la Rouge (throughout his life he was to be attracted to red hair).

By the end of the 1880s, Lautrec's pattern of living was set, and it was to continue with minor variations until his death. Despite his small stature, he was a man of enormous energy, who could make do with very little sleep. He spent his time rambling from nighttime entertainment to nighttime entertainment, surrounded by a little court whose most conspicuously faithful member was his cousin, Dr Gabriel Tapié de Céleyran (Plate 22). Despite his appearance, Lautrec was not without the consolation of female company. His sexual energy, too, was immense. He described himself jokingly as 'a coffee-pot with a large spout'. But the girls he went with were never those of his own class, and rarely was there any pretence of love. One of the few for whom he seems to have felt real affection was Suzanne Valadon (Plate 3), well-known as a model, and in secret a painter herself. The affair, marked from the outset by violent quarrels, broke up when Lautrec began to think that Suzanne was exploiting him on the instructions of her mother.

The painter not only lived hard; he ate and drank enormously. By the middle of the 1890s, he was an alcoholic, and by 1898 chronic alcoholism was taking its toll of his art. In February 1899 he had an attack of delirium tremens, and had to be taken to an asylum in Neuilly. He stayed there until May, and got his release partly thanks to the amount of work he produced in an effort to prove his sanity. But he soon started drinking again. In August 1901, while on holiday in the country, he was struck down by a paralytic stroke, connected either with his alcoholism or with the syphilis from which he had long suffered. Three weeks later he died at his mother's house.

There is, within the relatively brief span of his activity as an artist, a discernible pattern of development in Lautrec's work. It can be traced in two ways. First, through a gradual change in subject-matter. Secondly, through changes in technique. Lautrec began as a painter of dance-halls and cabarets; a poster done for the Moulin Rouge in 1891 (it had opened its doors in the autumn of 1889) marked the beginning of his reputation with his contemporaries. Even today, people tend to associate him with dance-hall scenes, perhaps because the paintings, prints and posters dealing with this theme are the liveliest things he ever produced, and are connected with the image of 'gay Paree' with which Lautrec has been vulgarly associated. Yet he was already losing interest in Montmartre as early as 1892, and when he reverted to painting the Moulin Rouge in the middle of the decade, it was partly as a favour to La Goulue, who wanted some panels for a booth she had opened at the Foire du Trône. This was the kind of commission that was bound to tickle Lautrec's fancy. He produced what she wanted, and mischievously included a portrait of Oscar Wilde, whom he had recently met while on a visit to England, among the spectators (Plate 30).

From his fascination with Montmartre Lautrec progressed in two directions. The stars of the café-concerts now took the place of the virtuoso can can dancers at the centre of his private pantheon. Chief among them was Yvette Guilbert. He also began to take an interest in theatre scenes in general as material for pictures. The other direction led towards the licensed brothels. Lautrec became obsessed with the secret life behind their closed doors, and began to paint the girls in their off-duty moments. In 1894 he went so far

as to take up residence in a newly opened and very splendid brothel in the Rue des Moulins, and used the main reception room as the subject for one of his most ambitious compositions (Plate 36). One facet of life in these establishments was the way the girls, starved of real affection by the very nature of their profession, turned for consolation to one another. Lesbian love-affairs were commonplace in the *maisons closes*, and these, too, Lautrec depicted – for example in *Les Deux Amies* (Plate 26). An interest in lesbian behaviour as he saw it in the brothels led him, towards the end of his career, to frequent some of the best known lesbian bars, and he did paintings and drawings inspired by what he had seen there.

This by no means exhausts the range of the subjects Lautrec chose to tackle, though it always remained fairly restricted. In 1895, he had a brief passion for the newly fashionable sport of bicycling, and attended the bicycle races at the Vélodrome Buffalo, which was managed by the writer Tristan Bernard. He did circus scenes – nearly forty of them when he was in the asylum at Neuilly – and there are portraits of friends and a few pictures connected with racing and yachting. One thing which didn't interest him at all was landscape, though there are a few landscape sketches dating from the early 1880s, when he had not yet found his true path.

Lautrec's interest in the stage naturally affected his technique. He was particularly fascinated by stage lighting, which in his day remained crude, and was adept at rendering its harsh effects. He was especially interested by the way in which the footlights (many café-concerts, in particular, had stages lit by footlights only) revealed whole new systems of protuberances and hollows in the faces of the performers.

Lautrec's technical progress was marked by the absorption of a number of outside influences, and also by a process of experiment and discovery which lasted until the middle 1890s, and which only began to flag as alcoholism increased its grip on him. He was, in particular, influenced by Japanese prints, which were then becoming fashionable in Europe. Lautrec saw a large exhibition of these at the Galerie Georges Petit in the spring of 1883, and immediately started to make a collection. He even spoke of going to Japan. His mother approved of the project, and offered to give him the fare. Lautrec declined, because he thought he had not as yet learned everything he could in Cormon's studio. In 1896 he was still toying with the idea of making the trip.

The attraction of Japanese art, so far as Lautrec was concerned, was precisely the same as its lure for some of the most gifted of his contemporaries, among them Degas and Van Gogh. From the *ukiyo-e* printmakers he learned not only how to use flat colour areas, bounded by a definite outline, but how to choose a point of view that enabled him to express a personal vision of the subject. The great Japanese printmakers, such as Utamaro, picked their angle to intensify the spectator's experience of what was being shown. Lautrec followed their example. Figures and objects that loomed large in the foreground of the composition might, so he discovered, play only a subsidiary part in the meaning of the whole, yet might nevertheless direct the attention to precisely the right spot. Similarly, he learned from the Japanese how the visible detail or fragment may be used to conjure up an unseen whole. Yvette Guilbert's famous shoulder-length gloves took the place of the singer herself.

Lautrec was on the whole less slavishly dependent on Japanese printmakers than some of his contemporaries. He never produced actual paraphrases of Japanese art as Van Gogh did. But in spirit he was closest of all to *ukiyo-e* artists. Like them, he was interested in

the stage, and his paintings and lithographs showing performers are exactly equivalent to the actor prints that formed so large a part of their output. He sought intensity in actors or singers at work; so did Sharaku, the greatest maker of Japanese actor-prints. Lautrec's fascination with life in the Parisian *maisons closes* similarly runs parallel to Utamaro's depictions of the activities of the geishas and their attendants.

But Lautrec did not learn from the Japanese alone. He felt the impact of his contemporaries. Among artists senior to him, the one he admired most was Degas. What Lautrec took from Degas was the determination to search for a truthful vision of ordinary life. It was Degas who directed him in his explorations of the world of the theatre and the circus. And Degas was interested, long before Lautrec, in new methods of composition suggested not merely by Japanese prints, but by photography. Lautrec was always hoping for a word of praise from the older master. When it came, however, it was ambiguous. Degas, seeing a work by Lautrec hanging in the apartment of mutual friends, remarked: 'To think a young man has done this, when we have worked so hard all our lives!'

Jean-Louis Forain is another and lesser artist from whom Lautrec learned something. He had been aware of Forain's talent from an early age, since Forain was a friend of his father, Count Alphonse. What Lautrec took from him was an awareness of the virtues of draughtsmanship that verged on caricature. Through Aristide Bruant, who hung some examples on the walls of the Mirliton, he also knew the work of Alexandre Steinlen, another artist with a caricaturist's gift for catching the essence of Parisian scenes. These two lesser painters inspired and guided him when he was given commissions for poster-designs; they led him towards the kind of bold simplification that would make a poster 'tell' to the uttermost, no matter where it was placed. His poster work encouraged him to make simplifications also in his paintings.

One other influence should be mentioned here: that of Lautrec's friend Van Gogh, whose system of bold cross-hatching in paint undoubtedly contributed something to Lautrec's methods. Lautrec was not merely an outstandingly able draughtsman; the bones of his draughtsmanship were more clearly visible in everything he did as a mature artist than was common with his contemporaries. The energy to be found in his canvases, despite their bright and simple hues, was not the energy of colour so much as the energy of line. This savage linear energy was indeed one of the things that most clearly separated him from others.

A discussion of Lautrec's influences leads directly to a discussion of his place in the general history of late nineteenth-century painting. The strangeness of his physical appearance was to some extent matched, despite his ability to learn from his contemporaries, by the isolation of his art. The only artist with an even remotely similar viewpoint was Degas, and no doubt this was the reason Lautrec worshipped him. Like Degas, Lautrec seems to have regarded human beings as animals, creatures without any spiritual dimension worth considering. This attitude had its roots in his physical deformity, and was confirmed by his initial training in the atelier of an animal painter. Of all artists, sporting painters have the greatest detachment from their subject-matter. They aim to tell a scientific kind of truth, and their patrons are more interested in truth of this sort than they are in artistic content. This applies to Princeteau's own work and still more to that of the better-known John Lewis Brown, whom Princeteau taught Lautrec to admire and emulate.

There is, however, a difference between the objectivity of Degas's subjects and that of Lautrec's. Degas was intensely interested in the commonplace. More and more he came

to paint people (nearly always women) engaged in their daily tasks – ironing, washing themselves – and quite unconscious of the presence of a spectator. Even when Degas painted dancers, he was showing what to him was a form of work. (His ballerinas are notoriously ungraceful, and are sometimes quoted by dance-historians to demonstrate the depths to which the ballet had fallen in France before the arrival of Diaghilev and his Ballets Russes).

Lautrec did occasionally paint people who were introspectively sunk into themselves, but more often he was interested in the reverse: the quality the performer possesses when he or she is projecting emotions and ideas, above all personality, to an audience in the most forceful possible way. His portraits of Yvette Guilbert are obvious examples. Lautrec was also interested in the way the performer's mood can be reflected in those who are watching or listening. Finally, he noted the way in which the star performer unconsciously radiates her attraction even before she has begun to perform, or after the performance is over.

Lautrec's legend has him keeping company with nothing but can can dancers, models and tarts. Of course this was far from being the case. Some of the performers he most admired were people of taste, intelligence and sensibility. Besides, he did not in any case live entirely in the world of the brothel, the dance-hall and the theatre, and he never severed his links either with his family or with the world of well-bred, cultivated people.

One salon he frequented was that of the beautiful Misia Natanson, a young Polish girl who was then married to Thadée Natanson, the founder, with his brother Alexandre, of the Symbolist periodical *La Revue Blanche*. Among the others who came to the same house were the poets Mallarmé and Valéry, the art-critic Félix Fénéon, the writers Colette, Jules Renard and Henri de Régnier, the composer Debussy, and the painters Vuillard and Bonnard. In fact, almost every artistic personality worth meeting in the Paris of the time was there at one moment or another.

Young as she was – or perhaps it was because she was so young – Misia was an accomplished breaker of hearts. Lautrec often stayed with her at her country house, as well as visiting her in town, and in a book of memoirs written in old age she gives a charming account of how they sometimes spent their time together: 'I would sit on the grass, leaning against a tree, engrossed in some entrancing book; he would squat beside me, and, armed with a paintbrush, dexterously tickle the soles of my feet. This entertainment, in which his finger sometimes played a part at propitious moments, sometimes lasted for hours. I was in the seventh heaven when he pretended to be painting imaginary landscapes on my feet.'

Lautrec's connection with the *Revue Blanche* gives us a guideline when we come to consider his artistic orientation. His fellow-student Emile Bernard had gone on to become one of the founders of the group who called themselves the Nabis (Nabi being the Hebrew word for prophet). It was he, indeed, who had been responsible for erecting some of Gauguin's ideas into a systematic doctrine, and he and his associates had become one of the many sects into which the Symbolist movement was divided. Bonnard and Vuillard, Misia's court painters, also belonged to the group. Bonnard in particular makes an interesting comparison with Lautrec, not least because their histories touch at several points other than this. They both designed posters for the Natansons' magazine (Lautrec's featured a portrait of Misia herself), and they had already exhibited together as early as 1891. In 1893 they made a joint appearance in a print portfolio put out by *L'estampe*

originale. This contained work by a large number of Symbolist artists – Bernard, Eugène Carrière, Maurice Denis, Puvis de Chavannes and Odilon Redon. Gauguin was also included. Like Lautrec, Bonnard was a pioneer in poster design, and there is even some argument as to whether or not certain innovations should be credited to him rather than to his contemporary and rival. But the resemblances go deeper than this. Because Lautrec's brothel scenes are in the conventional sense sordid, we tend to forget that they are as intimate as Bonnard's interiors. Lautrec's obsession with women is echoed in Bonnard's long series of paintings showing women washing themselves, which are far more erotic than similar scenes by Degas. Indeed, the more closely one studies the work of these two painters, the more convinced one becomes that they took a similar view of art and its possibilities.

Lautrec is now generally put forward by his admirers as an unsparing realist. A present-day art historian compares him both to Caravaggio and to Courbet and asserts that his achievement was 'to release painting from all its current taboos'. He continues: 'The extraordinary thing about Lautrec, or rather the thing that made him seem extraordinary to the public of his day, was that he alone, among all the painters of that period, set down exactly what he saw, without evasions, without comment and without distortion. In contrast to the erotic, suggestive art of the eighteenth- and nineteenth-century *petits maîtres*, Lautrec shows life as he saw and experienced it.'

This view is utterly inadequate. In the first place, the opening sentence is simply wrong: Degas made monotypes of brothel scenes, and Courbet painted pictures showing lesbian activities; both artists were as objective as anyone could wish. Secondly, the judgement is grossly oversimplified. An attempt to analyse Lautrec's art must proceed towards a single centre from several different directions at once. One of these is purely personal. Lautrec was so grossly crippled physically that his disabilities necessarily reflected themselves in his painting. He was a man of immense courage, and he did not react by becoming bitter. The view he took of women was considerably less harsh than that of the misogynistic Degas. For Lautrec it was personality that counted: he relished the greedy energy of La Goulue, the wit of Yvette Guilbert, the babyish perversity of May Belfort, but without trying to make any distinction between these qualities. The reason why he stopped short was clearly sexual. Cursed with a huge sexual appetite, he saw himself as someone forever debarred from forming any kind of personal relationship. He thus saw women with sympathy, but also with an almost total detachment, rooted in a refusal (perhaps less admirable than it seems at first) to construct moral hierarchies or to say that one mode of behaviour was preferable to another. The only thing that ruffled the surface of this detachment was voyeurism. Lesbians played so prominent a role in his painting not only because he happened to come in contact with them, but because they have commonly fascinated men who have doubts about their own sexual adequacy.

As for the artistic ethos of the time, it is usual to place Lautrec in the naturalist tradition, and to see him as the heir of Courbet, though admitting at the same time (because the fact is so obvious) that his pictures are devoid of social indignation. To say that they are devoid of comment is another matter. Lautrec was born an aristocrat and remained one, even in small matters such as the tyranny he exercised over his drinking companions and friends. One of the things most frequently misunderstood about him is the aristocratic tendency of his art. Like his father, Lautrec was indifferent to public opinion. And, once again like his father, he felt that it was quite all right to pursue a course of action – such as taking up

9

residence in a brothel – which would have seemed disgraceful in others. But he never courted scandal in the manner of a bourgeois painter in rebellion against his own background. When he exhibited *Elles,* the series of lithographs which show the life of the brothel and its inhabitants, he was careful to do so in such a way that they were available only to those who would not be shocked by them.

As we have already seen, Lautrec maintained links of friendship with many members of the Symbolist generation to which he himself belonged. When he exhibited his paintings or published his prints they tended to appear in a recognizably Symbolist context. For example, the Brussels 'Vingt', which so consistently supported him, was a great force in the dissemination of Symbolism. These are not accidental conjunctions. It is conventional wisdom to see the Symbolist painters as the purveyors of an extraordinary dream-world, in total contrast to the photographic naturalism of the Salon. The position of the Impressionists, exponents of a naturalism that was not academic, is left unresolved between these two divergent currents. The difficulty which arises here is the general ignorance which now prevails concerning what the Salons actually contained.

They did show large numbers of pompous portraits (as painted by Bonnat), of historical costume pieces (as painted by Cormon), and of the flimsily draped nudes that satisfied the covert erotic feelings of bourgeois visitors, but they also contained much that fell into none of these categories. The numerous depictions of contemporary life produced annually by highly competent academic artists covered the whole of the social spectrum. There is in fact some evidence that in French official exhibitions the pictures on working-class themes somewhat outnumbered those that showed the cosseted existence of the more prosperous. Nor were these pictures, as one might expect, heavily humorous or else sentimental. They took a notably clear-eyed view of the urban proletariat, as well as of the rural labouring class that formed a more traditional subject for picture-making. These artists were the heirs of mid-century naturalism, and the true successors of Courbet. It was their painting, too, that, while often eschewing overt comment on what it showed, made reference to a moral centre.

Lautrec's typical subject-matter was not the working-class as such, but those who live on the margin of society. His dancers, as much as his whores, were marginal people, picking up an untypical living. People of this kind had certainly found a place within the naturalist spectrum. We find them well represented in the great panorama of Zola's fiction. But it is not Zola who prompts a comparison with Lautrec – it is Maupassant. The inhabitants of Maupassant's *Maison Tellier* are recognizably the same as the girls who appear in Lautrec's brothel-scenes. Maupassant's transpicuous prose, the ironic detachment with which he manipulates his plots, alike remind us of the qualities we find in a painting such as the famous *Salon in the Rue des Moulins* (Plate 24). And this is significant because there is some dispute about Maupassant's precise relationship to the naturalist movement in literature.

In any case, it is an error to suppose that recognizably Symbolist writers avoided the realistic. Huysmans, when he abandoned his earlier style (which had been an imitation of Zola) to write *Là-Bas* and *A Rebours,* did indeed seem to step from one realm to another, though the distance he moved was no greater than that between Flaubert's *Madame Bovary* and the same writer's *Tentation de Saint Antoine* and *Salammbô.* But it is Flaubert who has the better claim to be one of the tap-roots of Symbolism, and Flaubert never abandoned interest in everyday reality. One branch of Symbolist literature concerned itself with

intensely realistic, sordid and wilfully 'shocking' material – Verlaine's erotic poems are a case in point. The difference was that these works were no longer constructed around a moral armature of the old kind. The rarefied world of Symbolic vision was balanced against, and indeed compensated for, the interest in decadence. At their most hectic the decadents thought of themselves as being the victims of an irremediable sickness in society, and it was they who made a cult-figure of the prostitute, perhaps originally taking their cue from Baudelaire and certain poems in the *Fleurs du Mal*.

It can, of course, be argued that there is a great difference between Lautrec's robust version of low life and the kind of thing that openly decadent artists and poets made of it. This is quite true. What is not taken into account by this argument is one very significant aspect of Lautrec's approach to his material. Robust and incisive he may be, but he constantly manipulates, by means of devices taken from Degas and the Japanese, the spectator's attitude towards it. It is astonishing how seldom he allows us to look at anything from quite the expected point of view, at least in the physical sense. Unlike Caravaggio, to whom he has been compared, he is concerned, not to make us feel that we are in the presence of the scene itself, but that we are the witnesses of an act of transformation, the sea-change of life into art. This implies a typically Symbolist attitude towards what he painted.

This view is not invalidated, indeed it is strengthened, by a peculiarity of Lautrec's work. His sources and influences, as well as his subject-matter, are largely popular ones. His family background had led him to begin his career with a man who produced sporting pictures; this made an indelible mark. Sporting pictures, even raised to the plane to which Stubbs brought them in England, have the quality of being half-way between high art and popular or folk painting – which may be the reason that they have reached such heights of favour with mid-twentieth-century collectors. To the initial influence of Princeteau, Lautrec added those of Japanese prints and of the contemporary posters he saw in the streets. The first were certainly meant to reach a large public – they were originally sold for a few coppers in the streets of Edo. The second were popular by their very nature. Lautrec learned valuable lessons from designing posters, lessons that he proceeded to apply elsewhere, but his decision to undertake them at all was the really significant thing. By doing so, he was expressing an attitude towards the role of the artist. It was not incompatible with his essentially aristocratic attitude towards the image itself to wish to democratize it once it had been created. The urge towards the democratization of art was felt particularly strongly among Symbolists, for it was they who had become dissatisfied with the official Salons as a means of disseminating both works of art and artistic ideas. A division could be made, and often was, between the notion of 'art for art's sake' and what happened to the artist's product once it had come into existence. In Belgium, where Lautrec met so much appreciation, many of the leading Symbolists were also socialists, thus following in the footsteps of William Morris.

A better way of estimating Lautrec's achievement is to look not at its origins but at its parallels and consequences. An infrequently cited but very relevant parallel is provided by the work of the Norwegian Expressionist Edvard Munch, who came to Paris as a student in 1885, when Lautrec was just coming to the end of his own apprenticeship. Munch came again in 1889, and studied under Bonnat, just as Lautrec himself had done, then travelled back and forth between Norway and Paris until 1892, when he removed himself to Berlin. There is no evidence that he and Lautrec met, but Munch could

certainly have seen Lautrec's poster for the Moulin Rouge as it went up in the streets in 1891. Though Munch's most powerful compositions, many produced during the 1890s, are openly and deliberately symbolic, and have none of Lautrec's tendency to stand aside from the emotions, they do, in details of colour and handling, have a distinct resemblance to what the Frenchman was doing at the same moment. The cousinhood between Lautrec's big Moulin Rouge compositions and Munch's *Dance of Life* of 1899–1900 is very obvious. When one looks at Munch's paintings one often seems to see Lautrec's techniques taken a stage further in boldness and stylization, and this raises the possibility that Lautrec's apparent impassivity is trembling on the brink of turning into its opposite – that the mask of one of his performers might crack open into the anguished scream that Munch depicted.

When one speaks of the 'consequences' of Lautrec's work, one can look in one direction only – at his impact on the young Picasso. Picasso arrived in Paris for the first time about a year before Lautrec's death. The artistic ambience he came from, in Barcelona, was distinctly Symbolist, and Picasso was to remain a belated Symbolist right down to the middle of the first decade of the new century. But it was Lautrec whom he chose to follow when he first arrived in France, and there exists within his enormous oeuvre a small group of early paintings in Lautrec's manner, dating from around 1901. They are inferior to Lautrec's because they lack the keenness and directness of observation that Lautrec invariably put into his work. Picasso's courtesans are types, not individuals. Yet it is perfectly possible to argue that it is Lautrec's acrid harshness, as well as the lessons learned from Negro art, which comes to the surface again in the great *Demoiselles d'Avignon* of 1907, which, more than any other work, is the definitive announcement of the birth of the Modern movement. Lautrec's aristocratic sense of separateness, which was purely personal, is here transformed into a gesture of defiance directed against all previously held assumptions about the nature of painting.

The paradox is that the aristocrat is the one who democratizes art, by arrogantly removing from it any pretence at moral instruction. The art of the 19th century, from David onwards, was deeply involved in a debate about moral ideas. David's *Death of Marat* foreshadows the whole course of nineteenth-century painting, until the appearance of the Impressionists, and after them of Lautrec. But his effect is more drastic, because he is both amoral and urban. He shows us not nature, but man, and man as a social being. And, in effect, he then declares that human relationships are at bottom meaningless.

It can even be said that Lautrec brought painting to a position which foreshadows the basic problem of the Modern movement. How is the artist to remain true to the demands of his art, and yet fulfil the role of teacher which the nineteenth century still imposes on him? Lautrec's refusal to instruct, his aloofness from ideas about morality, make him a seminal figure in the history of nineteenth-century painting.

To try to restore Lautrec to his true position within Symbolism is in no sense to denigrate his achievement as an artist. Rather, it is an attempt to show why his work has retained its force. The mere fact that an artist chose to paint brothel scenes, and to give an unvarnished view of the way prostitutes behaved when they were alone together, might have been enough to shock the public of Lautrec's own time. We must beware of saying that it *did* shock them, since, despite occasional denunciations, Lautrec's career was free of the kind of major scandal that his subject-matter would certainly have aroused in England or in the United States. Today, however, his power to shock in this fashion is

much attenuated; and even the raunchy dance-halls and cabarets he painted are preserved only in sentimental folk-lore. Anything of them that remains alive is so because Lautrec chose to paint it.

The gallery of individuals he created is memorable because each of these individuals is projected so passionately by the paradox of the artist's own emotional reticence. His inner numbness set him free to look for the most expressive methods of rendering what he had seen. Conventional methods of constructing a head or a body could be sacrificed to the need to achieve maximum impact because ordinary humanity itself seemed remote. It is not his own feelings that the artist is trying to articulate; and the distortions he uses are not the product of the pressure of his own emotions (as they might be in Munch) but are imposed from outside, and spring from the inner urgency of the subjects themselves. The ultimate way in which his aristocracy of spirit showed itself was in his assumption that he could absorb any expression of individuality, however violent, into the larger individuality of his art.

Outline Biography

1864 Born November 24.

1872 Begins his schooling at the Lycée Fontanes (now Condorcet) in Paris. Starts to frequent René Princeteau's studio.

1878–79 Fractures his legs.

1882 Enters Bonnat's studio.

1883 Begins to work in Cormon's studio.

1884 Meets Emile Bernard.

1885 Meets Aristide Bruant and Suzanne Valadon, who becomes his mistress. Begins to frequent the Montmartre cabarets and dance-halls.

1886 Meets Van Gogh. Leaves Cormon's studio. Exhibits at the Mirliton.

1888 Exhibits with 'Les Vingt' in Brussels. Quarrels with Suzanne Valadon. Contracts syphilis.

1889 Exhibits for the first time at the Salon des Indépendants.

1890 Visits Brussels.

1891 Produces a poster for the Moulin Rouge.

1892 Makes his first lithographs.

1893 Becomes acquainted with the *Revue Blanche* circle. Begins to paint theatrical subjects.

1894 Again visits Brussels. Takes up residence in the brothel in the Rue des Moulins.

1895 Designs posters for May Belfort, May Milton, and the *Revue Blanche*. Paints panels for La Goulue's booth. Visits London and meets Oscar Wilde.

1896 Begins to visit lesbian bars. Publishes *Elles*, prints depicting prostitutes.

1898 Exhibits at the Goupil Gallery, London. Illustrates Jules Renard's *Histoires Naturelles*. His health begins to deteriorate.

1899 Taken to an asylum at Neuilly after an attack of delirium tremens. Stays there till May, and is released into the care of a guardian. Starts drinking again on his return to Paris in the autumn.

1900 Visits Le Havre, Arcachon and his mother's country house at Malromé in the Bordelais.

1901 Returns to Paris and does some painting. In August, at Taussat, has a paralytic attack. Is taken to Malromé, where he dies on September 9.

Bibliography

Adhémar, Jean. *Toulouse-Lautrec – Complete Lithographs and Drypoints*. London, 1965.

Bouret, Jean. *Toulouse-Lautrec*. London and New York, 1964.

Cooper, Douglas. *Toulouse-Lautrec*. London, 1955.

Dortu, M.G. *Toulouse-Lautrec et Son Oeuvre* (6 vols.). New York, 1971.

Julien, Edouard. *Les Affiches de Toulouse-Lautrec*. Paris, 1950.

Lassaigne, Jacques. *Lautrec*. Geneva, 1953.

Lucie-Smith, Edward. *Symbolist Art*. London and New York, 1972.

Mornand, Pierre. *Emile Bernard et Ses Amis*. Geneva, 1957.

Natanson, Thadée. *Un Henri de Toulouse-Lautrec*. Geneva, 1951.

Novotny, Fritz. *Toulouse-Lautrec*. London, 1969.

Perruchot, Henri. *Toulouse-Lautrec*. London, 1960.

Sert, Misia. *Two or Three Muses*. London, 1953.

Tietze, Hans. *Toulouse-Lautrec*. New York, 1953.

Toulouse-Lautrec, Henri de. *Elles*.

Toulouse-Lautrec, Henri de. *Unpublished Correspondence*. London, 1969.

List of Plates

1. *Artilleryman and Girl. c.* 1886. Oil on tracing paper, 57 × 46 cm. Albi, Toulouse-Lautrec Museum.

2. *Emile Bernard.* 1885. Canvas, 23 × 18 cm. London, Tate Gallery.

3. *Suzanne Valadon.* 1886. Canvas, 54·5 × 45 cm. Copenhagen, Ny Carlsberg Glyptotek.

4. *Jeanne Wenz.* 1886. Canvas, 81·3 × 59·1 cm. Chicago, Art Institute.

5. *Emile Davoust.* 1889. Cardboard, 45 × 35 cm. Zürich, Kunsthaus.

6. *Gabrielle.* 1891. Cardboard, 61 × 63 cm. London, National Gallery.

7. *Justine Dieuhl.* 1889–90. Cardboard, 75 × 58 cm. Paris, Louvre.

8. *'A la Mie'.* 1891. Cardboard, 70 × 50 cm. Boston, Museum of Fine Arts.

9. *Moulin Rouge – La Goulue.* 1891. Poster (coloured lithograph), 195 × 122 cm.

10. *Woman with a Black Feather Boa. c.* 1892. Cardboard, 53 × 41 cm. Paris, Louvre.

11. *Woman with Gloves (Honorine P.). c.* 1892. Cardboard, 50 × 40 cm. Paris, Louvre.

12. *Dance at the Moulin Rouge.* 1890. Canvas, 115 × 150 cm. Philadelphia, Collection Henry P. McIlhenny.

13. *Reine de Joie.* 1892. Poster (coloured lithograph), 130 × 89·5 cm.

14. *Head of the Englishman at the Moulin Rouge.* 1892. Cardboard, 58 × 48 cm. Albi, Toulouse-Lautrec Museum.

15. *The Englishman at the Moulin Rouge.* 1892. Lithograph, 47 × 37·2 cm.

16. *At the Moulin Rouge.* 1892. Canvas, 122·9 × 140·4 cm. Chicago, Art Institute.

17. *Jane Avril Pulling on Her Gloves.* 1892. Oil and pastel on cardboard, 102 × 55 cm. London, Courtauld Institute Galleries.

18. *Yvette Guilbert Taking a Curtain Call.* 1893. Watercolour, 41·9 × 23 cm. Providence, Rhode Island School of Design.

19. *Divan Japonais.* 1893. Poster (coloured lithograph), 79·5 × 59·5 cm.

20. *M. Prairice.* 1893. Cardboard, 51 × 36 cm. New York, Collection of André and Clara Mertens.

21. *Confetti.* 1894. Poster (coloured lithograph), 54·5 × 39 cm.

22. *Dr Gabriel Tapié de Céleyran.* 1894. Canvas, 110 × 56 cm. Albi, Toulouse-Lautrec Museum.

23. *Dance at the Moulin Rouge.* 1892. Oil on cardboard, 93 × 80 cm. Prague, National Gallery.

24. *The Salon in the Rue des Moulins.* 1894. Pastel, 111·5 × 132·5 cm. Albi, Toulouse-Lautrec Museum.

25. *The Card-players.* 1893. Cardboard, 57 × 44 cm. Berne, Hahnloser Collection.

26. *Les Deux Amies. c.* 1894. Cardboard, 48 × 34 cm. London, Tate Gallery.

27. *Woman Adjusting her Garter.* 1894. Cardboard, 58 × 46 cm. Paris, Louvre (Jeu de Paume).

28. *Loie Fuller.* 1893. Poster (lithograph coloured by hand), 43 × 27 cm. Paris, Bibliothèque Nationale.

29. *Aristide Bruant.* 1893. Poster (coloured lithograph), 127 × 92·5 cm.

30. Detail of Plate 33, showing Oscar Wilde.

31. *Oscar Wilde.* 1895. Watercolour, 58·5 × 48 cm. Beverley Hills, California, Lester Collection.

32. *La Goulue Dancing with Valentin le Désossé.* 1895. Canvas, 298 × 316 cm. Paris, Louvre.

33. *La Goulue Dancing ('La Danse de l'Almée').* 1895. Canvas, 285 × 307·5 cm. Paris, Louvre.

34. Detail of Plate 32.

35. *The Clowness Cha-U-Ka-O.* 1895. Cardboard, 64 × 49 cm. Paris, Louvre (Jeu de Paume).

36. *Women in a Brothel.* 1896. Cardboard, 60·3 × 80·5 cm. Paris, Louvre.

37. *Woman at her Toilet.* 1896. Cardboard, 52 × 40 cm. Paris, Louvre.

38. *Marcelle Lender, Standing.* 1896. Coloured lithograph, 35 × 24 cm.

39. *The Clowness Cha-U-Ka-O.* 1895. Cardboard, 87 × 60 cm. New York, Mrs. Florence Gould Collection.

40. *Paul Leclercq.* 1897. Cardboard, 54 × 67 cm. Paris, Louvre (Jeu de Paume).

41. *Marcelle Lender Dancing the Bolero in 'Chilperic'.* 1895. Canvas, 150 × 145 cm. New York, John H. Whitney Collection.

42. *In the Bar.* 1898. Cardboard, 81·5 × 60 cm. Zürich, Kunsthaus.

43. *The Sphinx.* 1898. Canvas, 85 × 65 cm. Zürich, Alfred Haussmann Collection.

44. *'Au Petit Lever'.* 1896. Lithograph from *Elles.* 40 × 52 cm.

45. *Elsa, Called 'La Viennoise'*. 1897. Lithograph, 48·5 × 36 cm.

46. *Tête-à-tête Supper*. 1895. Canvas, 55 × 46 cm. London, Courtauld Institute Galleries.

47. *The English Girl from the 'Star' at Le Havre*. 1899. Wood, 41 × 32·7 cm. Albi, Toulouse-Lautrec Museum.

48. *Scene from 'Messaline' at the Bordeaux Opera*. 1900–1. Canvas, 100 × 73 cm. Los Angeles, County Museum.

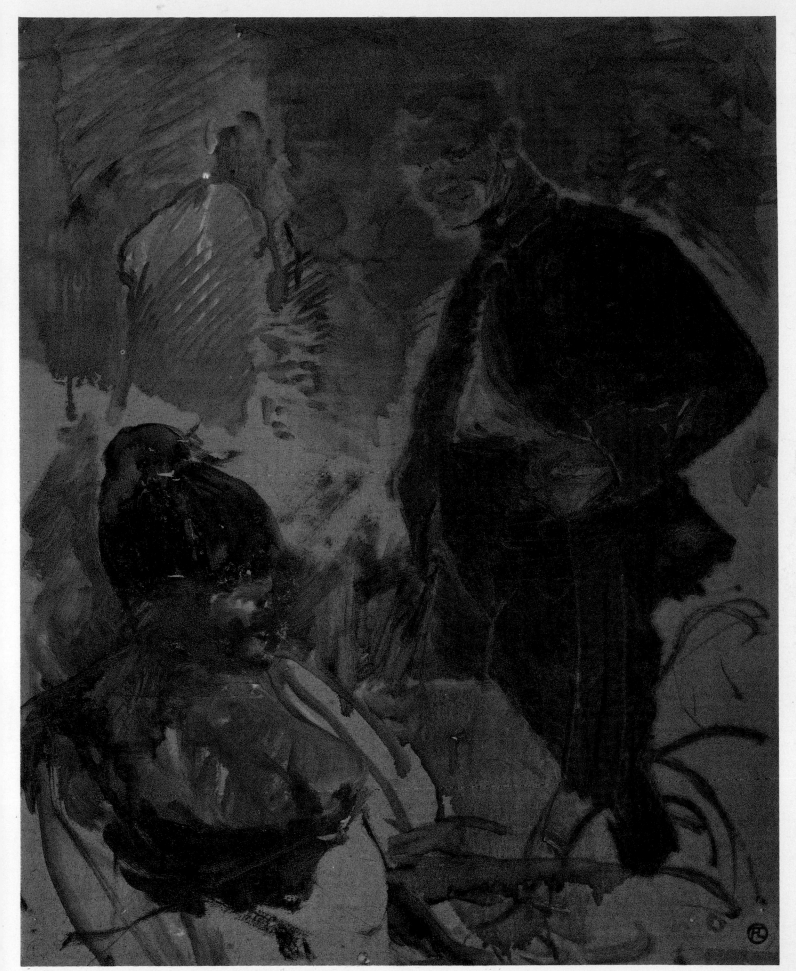

1. *Artilleryman and Girl. c.* 1886. Albi, Toulouse-Lautrec Museum

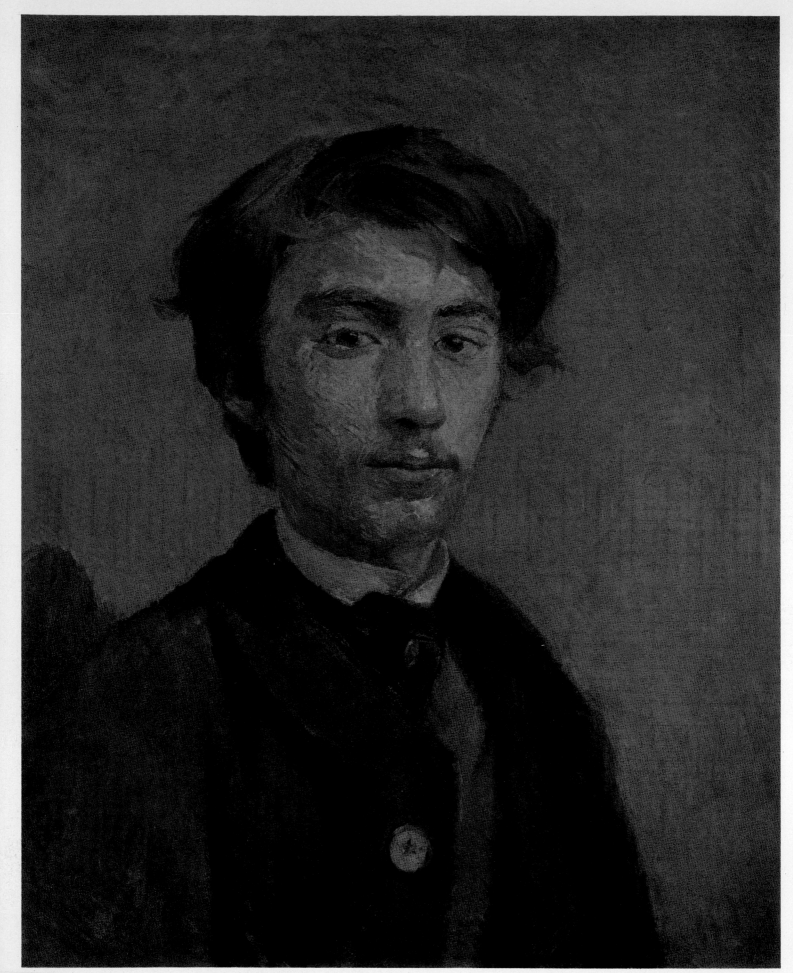

2. *Emile Bernard*. 1885. London, Tate Gallery

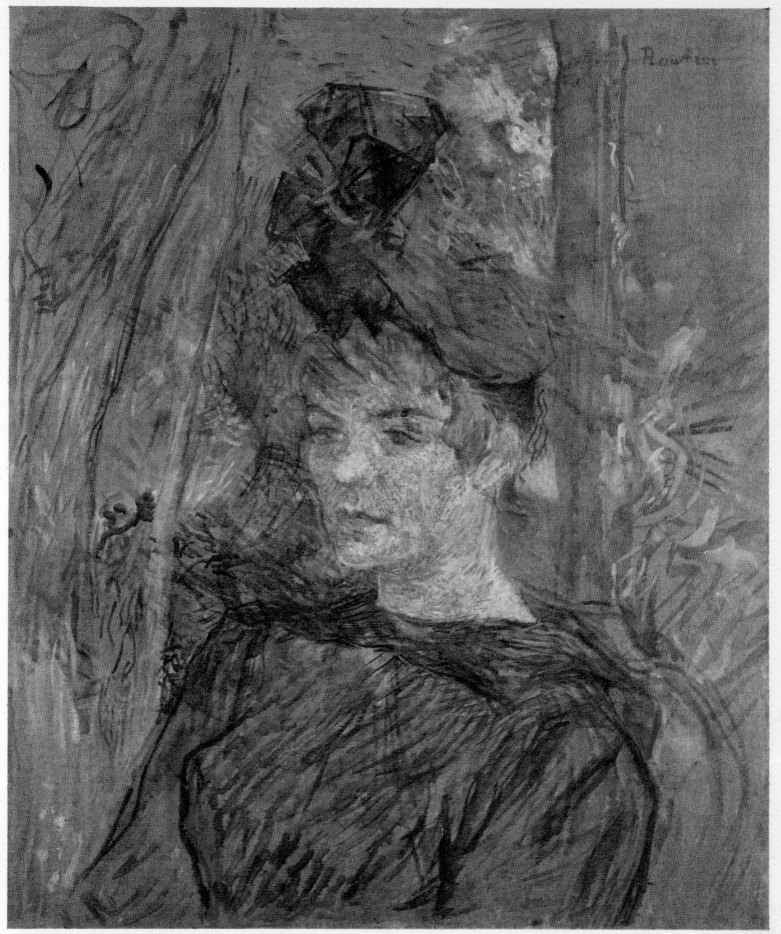

3. *Suzanne Valadon*. 1886. Copenhagen, Ny Carlsberg Glyptotek

4. *Jeanne Wenz*. 1886. Chicago, Art Institute

5. *Emile Davoust.* 1889. Zürich, Kunsthaus

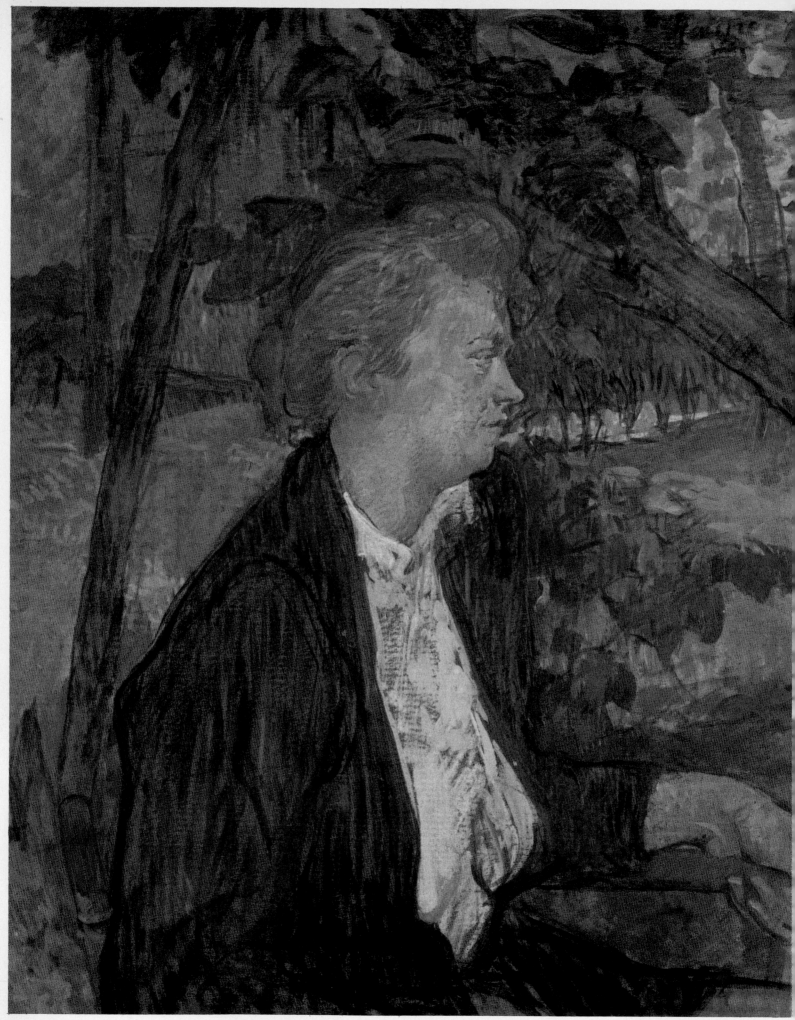

6. *Gabrielle*. 1891. London, National Gallery

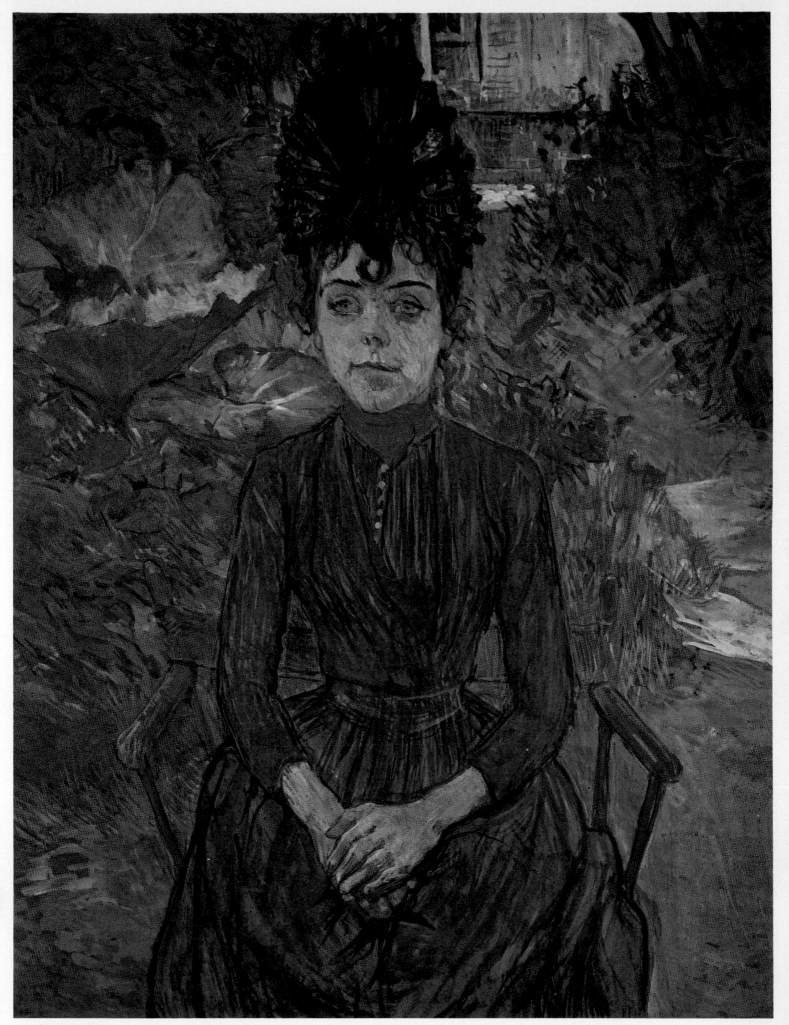

7. *Justine Dieuhl*. 1889–90. Paris, Louvre

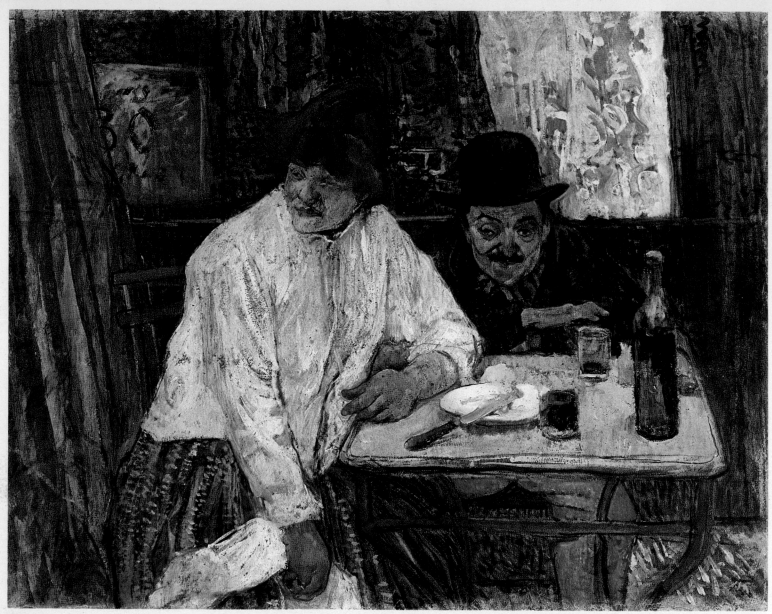

8. 'A la Mie'. 1891. Boston, Museum of Fine Arts

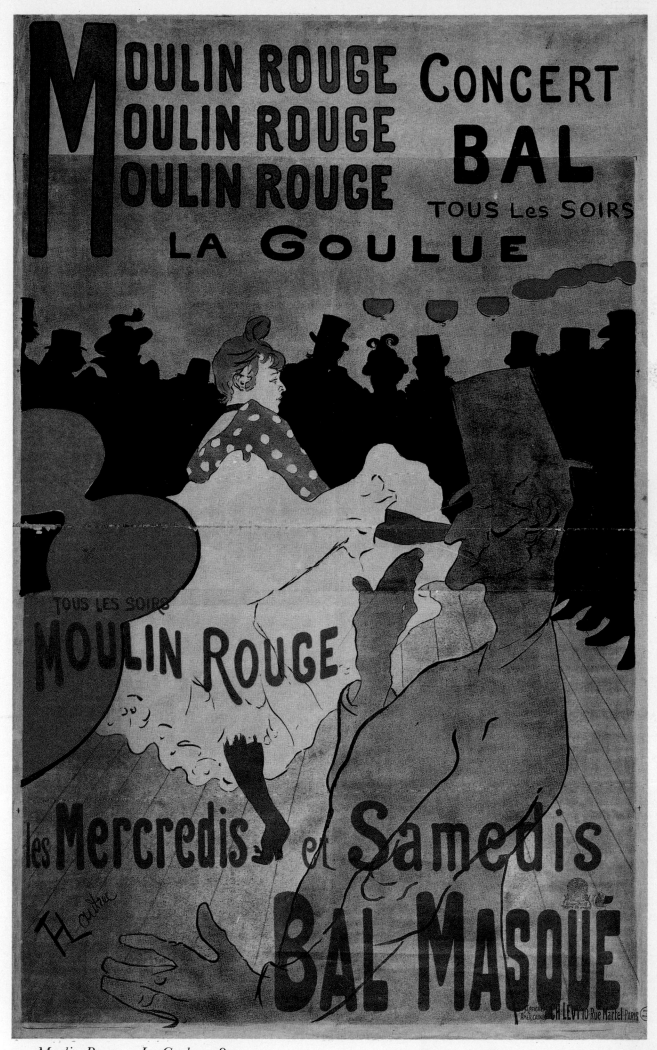

9. *Moulin Rouge – La Goulue*. 1891.

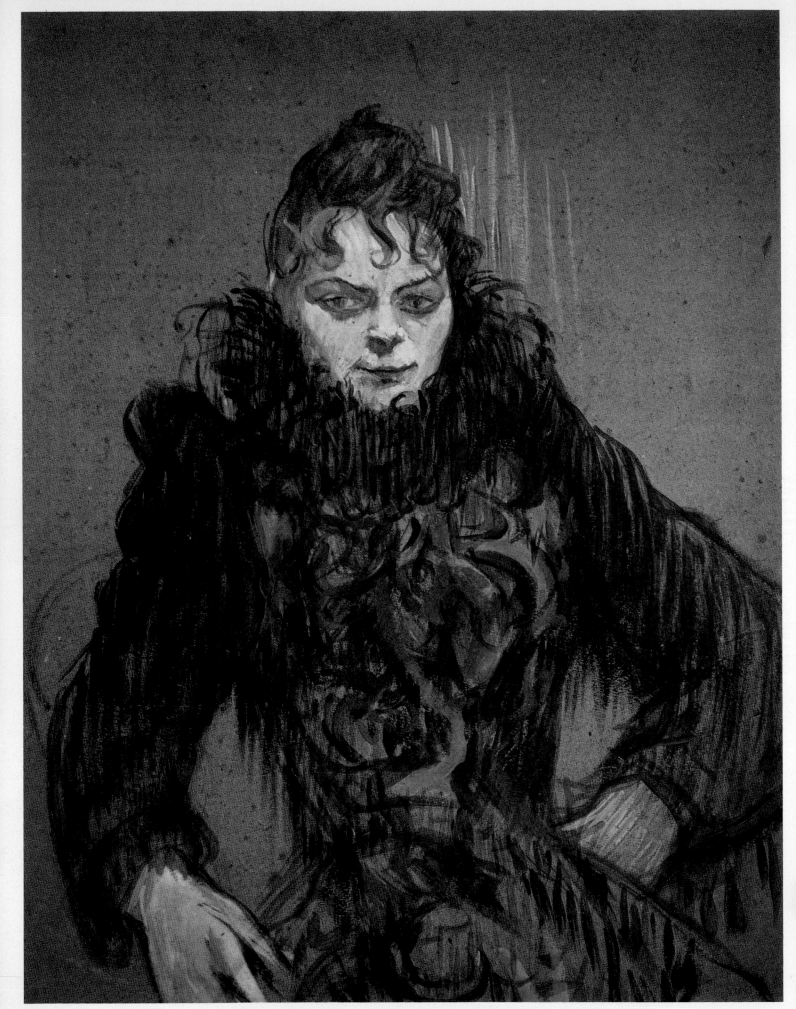

10. *Woman with a Black Feather Boa. c.* 1892. Paris, Louvre

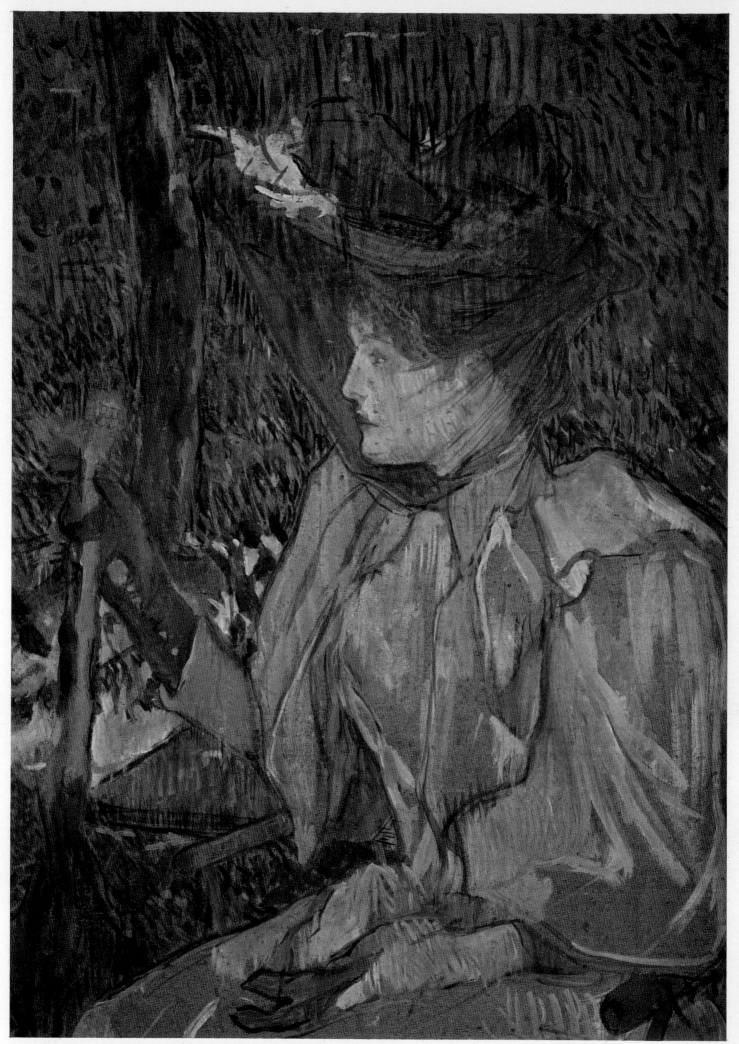

11. *Woman with Gloves (Honorine P.). c.* 1892. Paris, Louvre

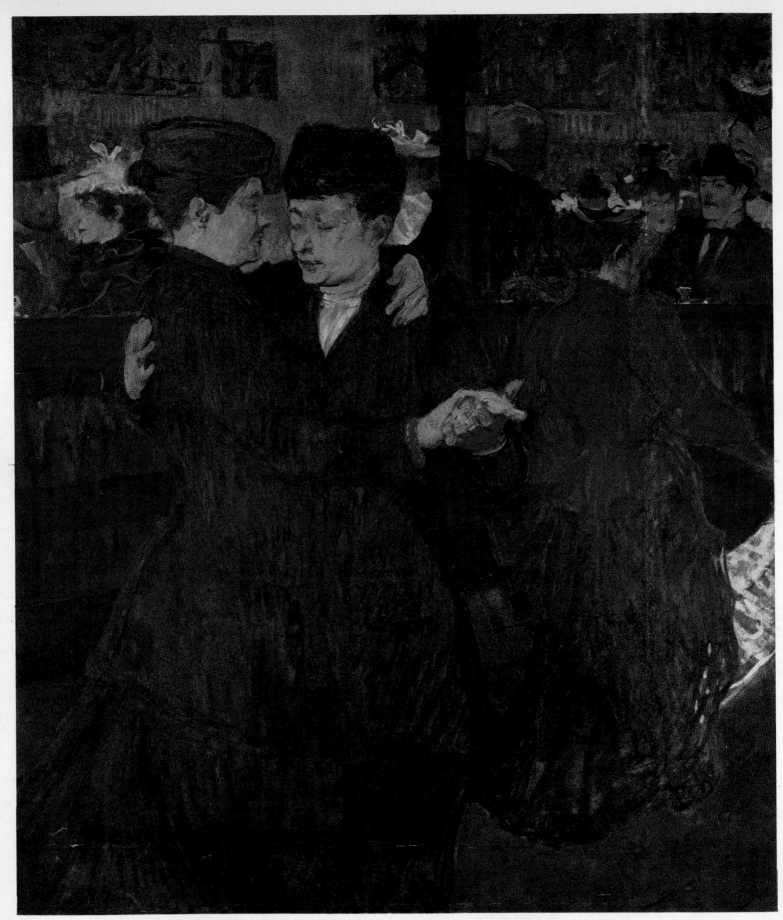

12. *Dance at the Moulin Rouge.* 1890. Philadelphia, Collection Henry P. McIlhenny

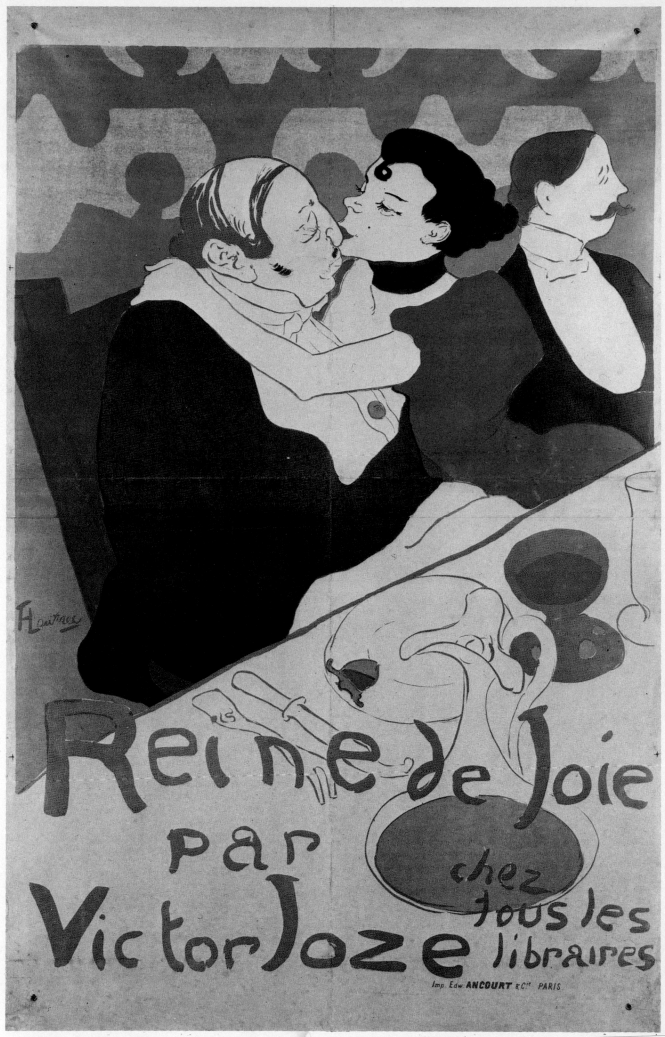

13. *Reine de Joie.* 1892

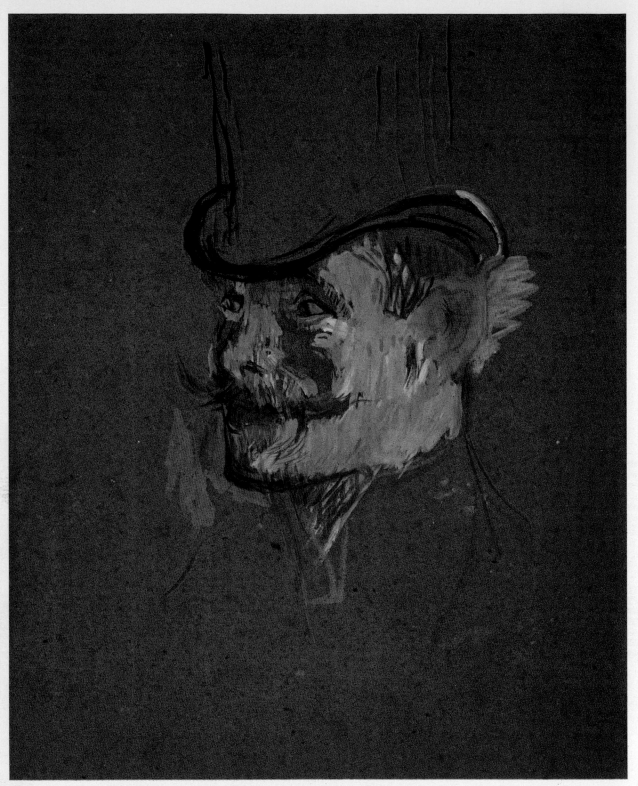

14. *Head of the Englishman at the Moulin Rouge.* 1892. Albi, Toulouse-Lautrec Museum

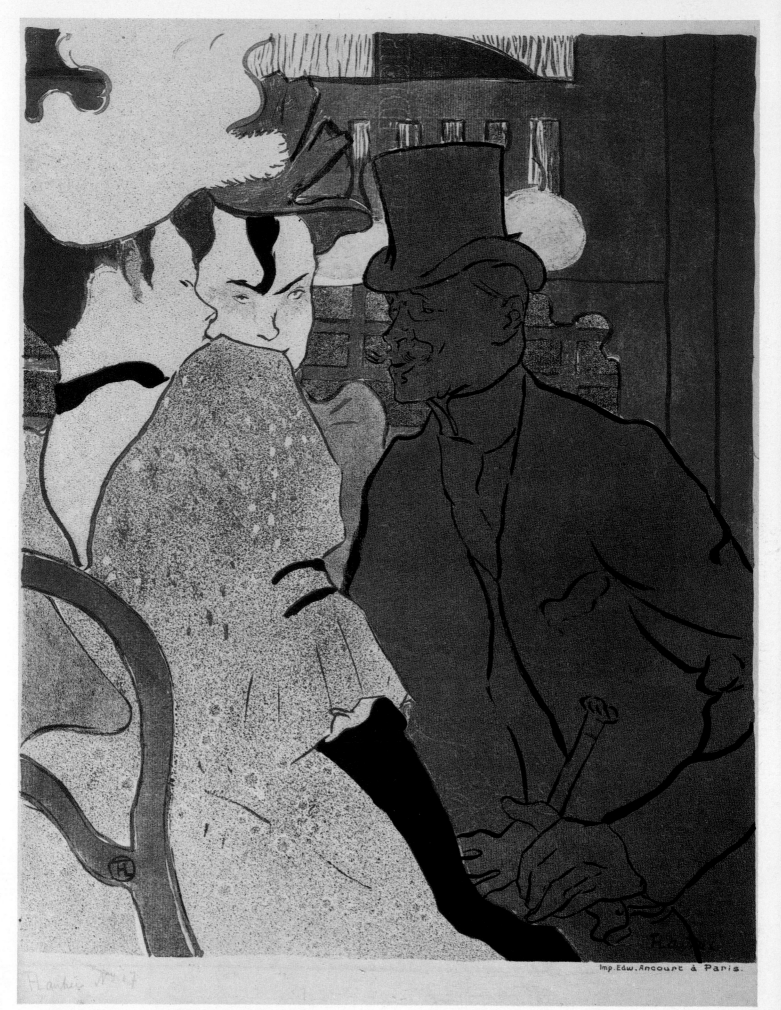

Imp. Edw. Ancourt à Paris.

15. *The Englishman at the Moulin Rouge.* 1892

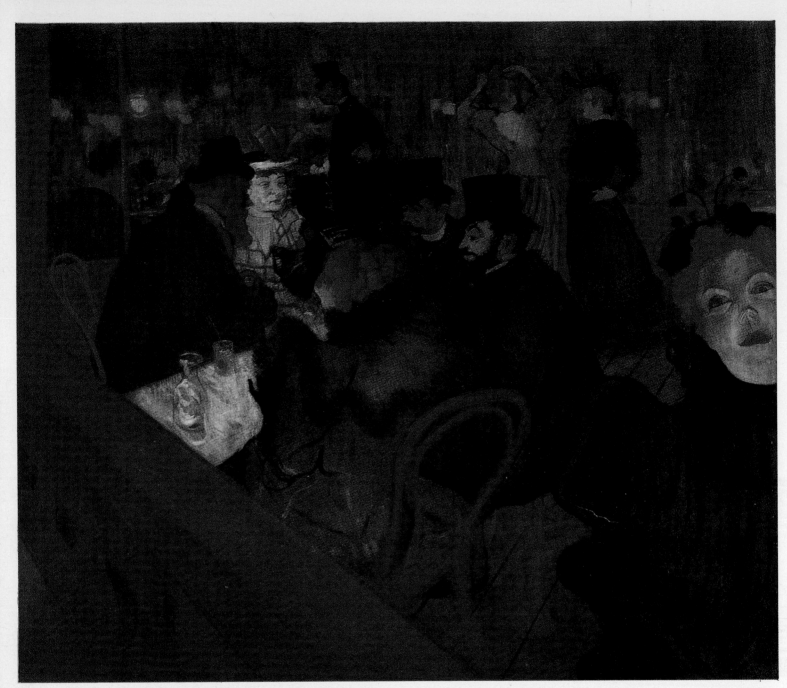

16. *At the Moulin Rouge*. 1892. Chicago, Art Institute

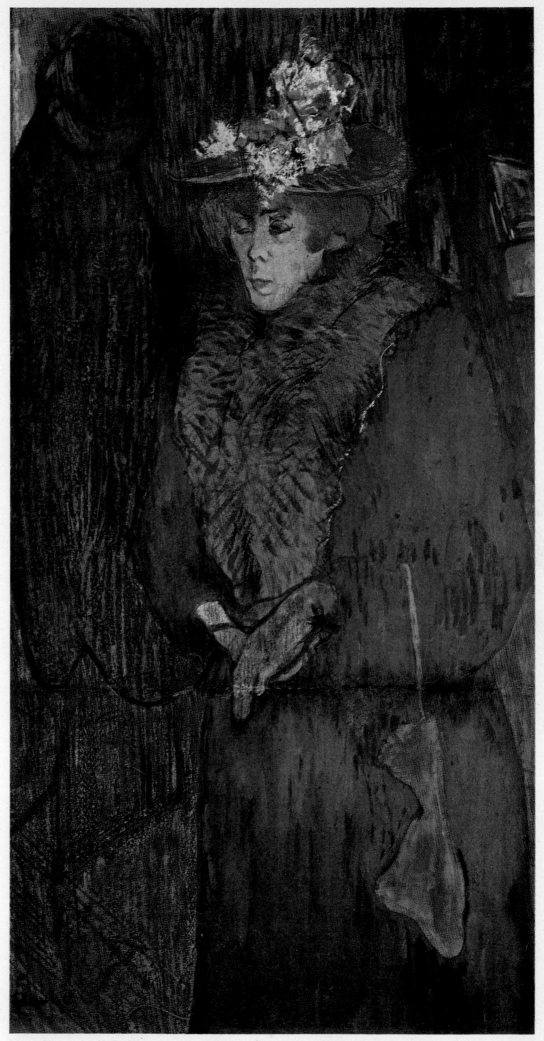

17. *Jane Avril Pulling on Her Gloves*. 1892. London, Courtauld Institute
Galleries

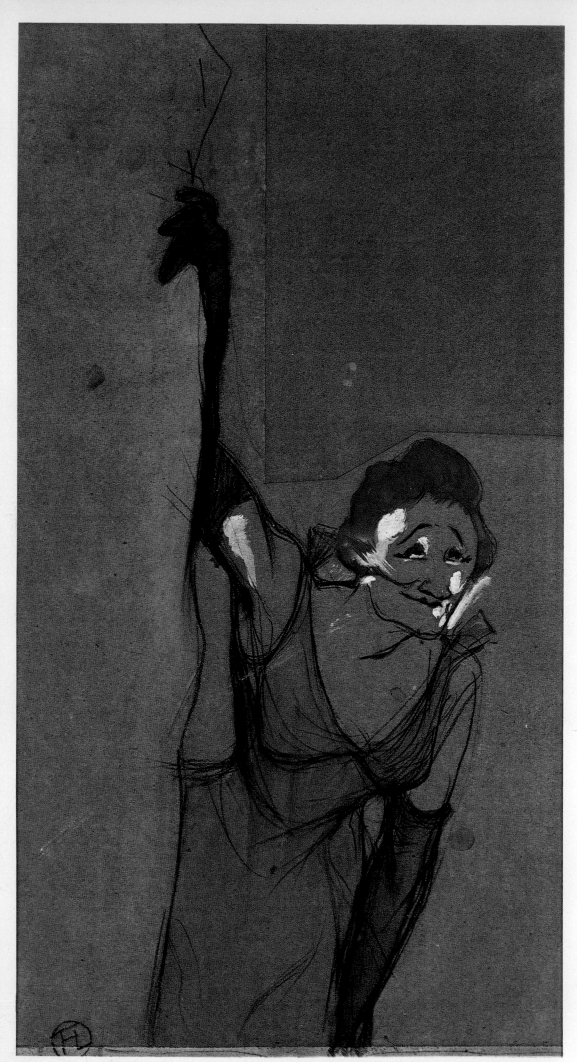

18. *Yvette Guilbert Taking a Curtain Call.* 1893. Providence, Rhode Island School
of Design

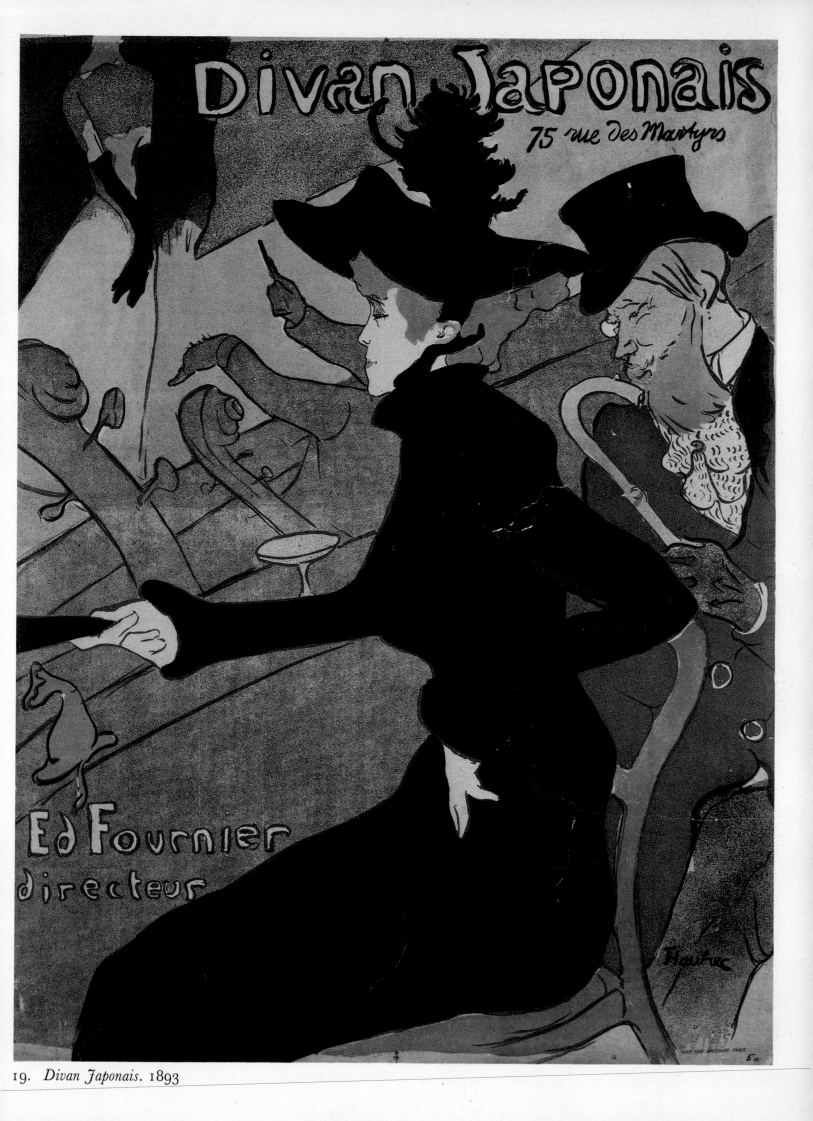

19. *Divan Japonais.* 1893

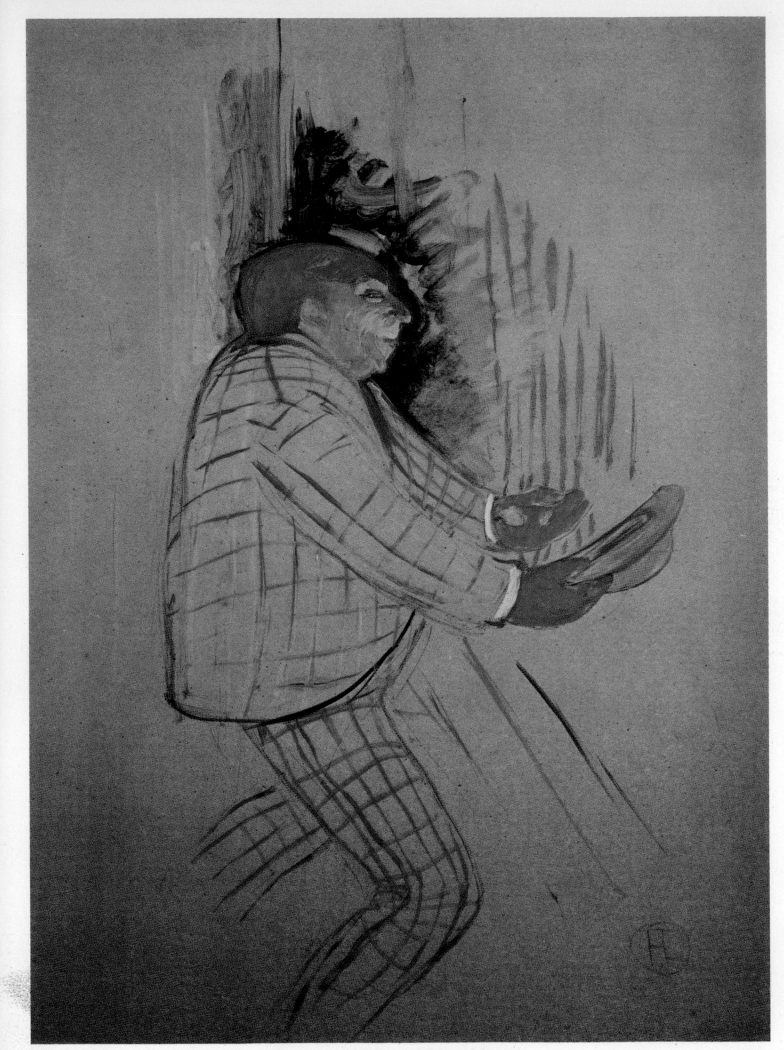

20. *M. Praince.* 1893. New York, Collection of André and Clara Mertens

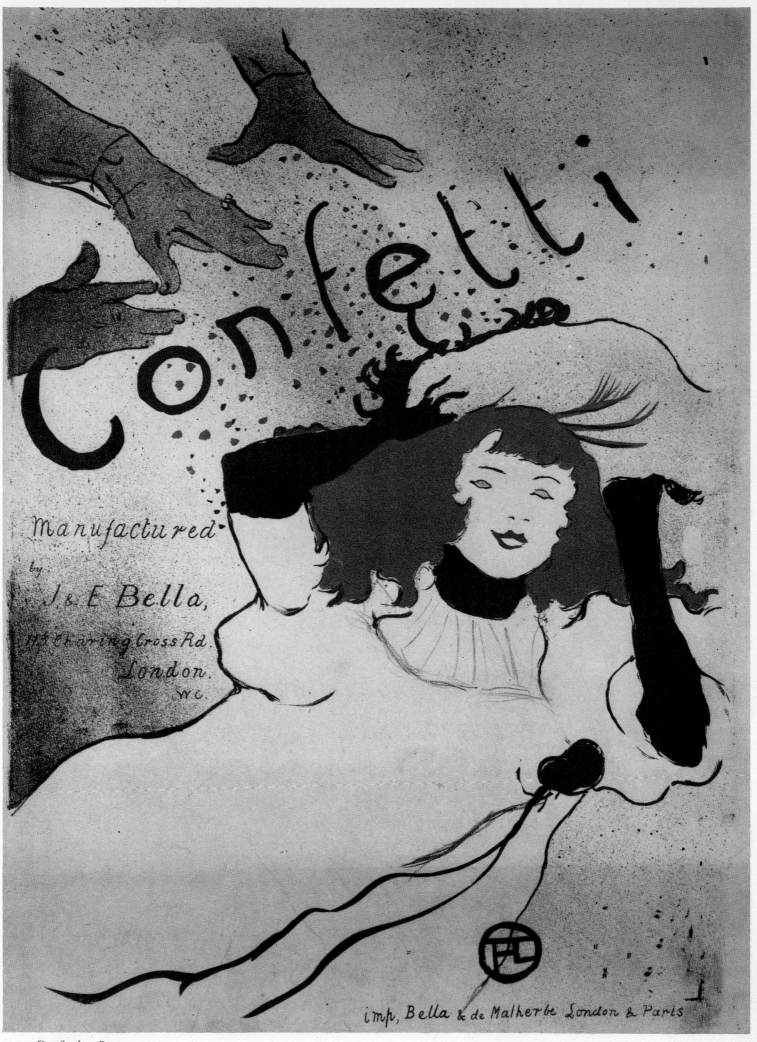

21. *Confetti.* 1894

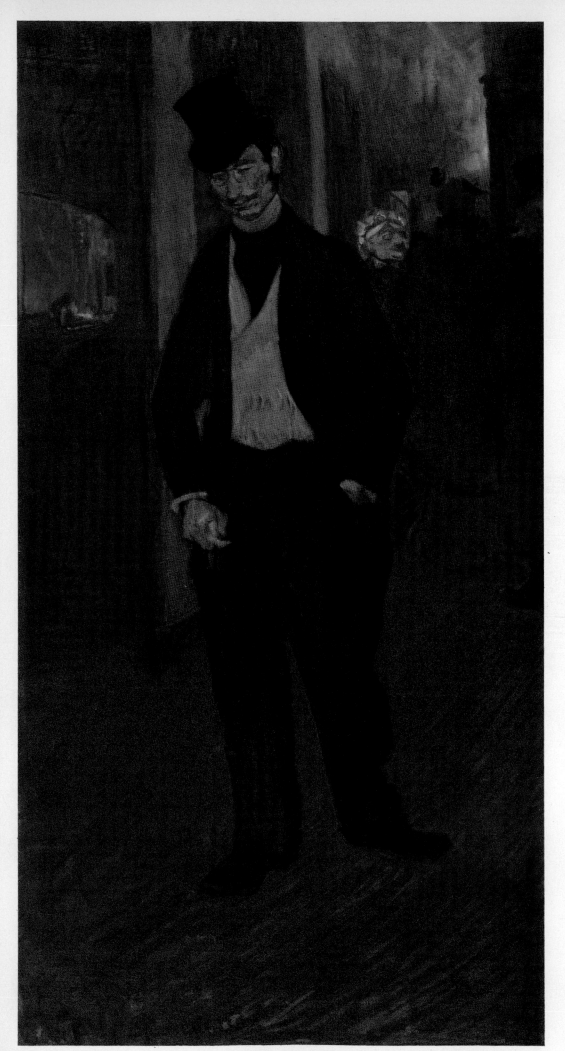

22. *Dr Gabriel Tapié de Céleyran*. 1894. Albi, Toulouse-Lautrec Museum

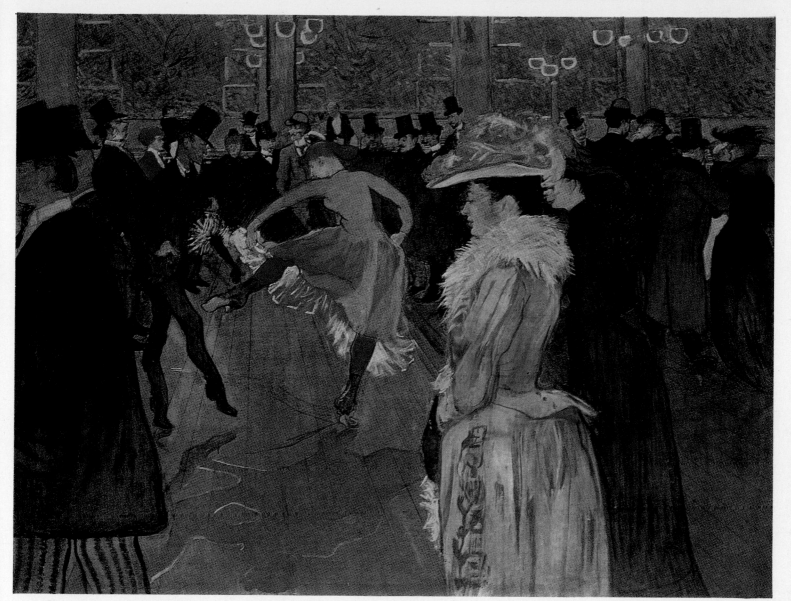

23. *Dance at the Moulin Rouge.* 1892. Prague, National Gallery

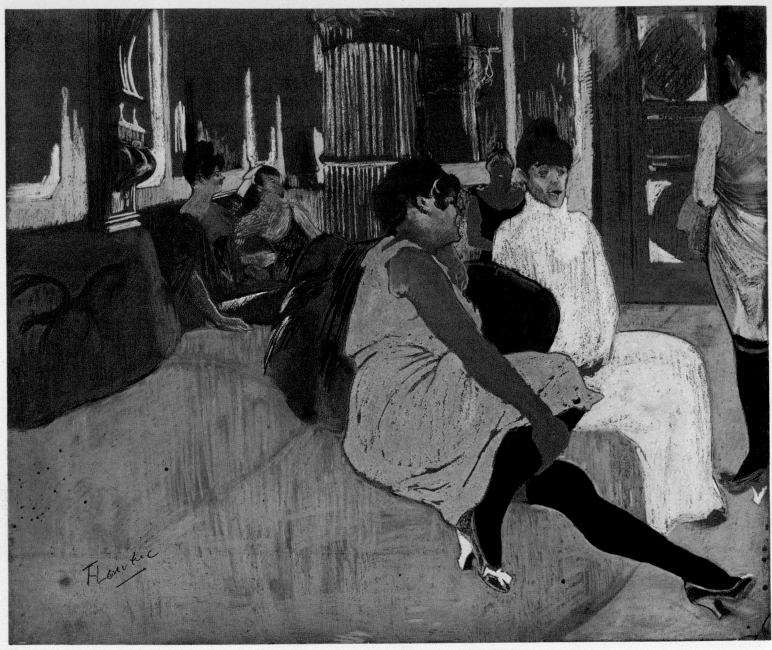

24. *The Salon in the Rue des Moulins*. 1894. Albi, Toulouse-Lautrec Museum

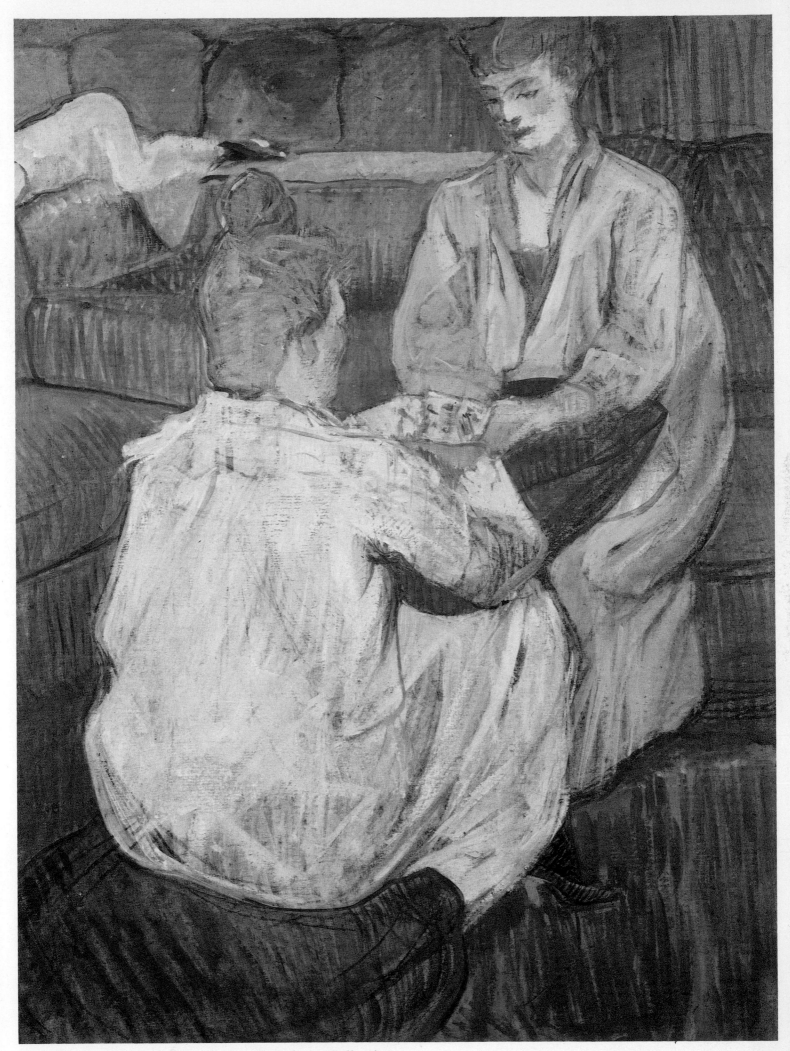

25. *The Card-players*. 1893. Berne, Hahnloser Collection

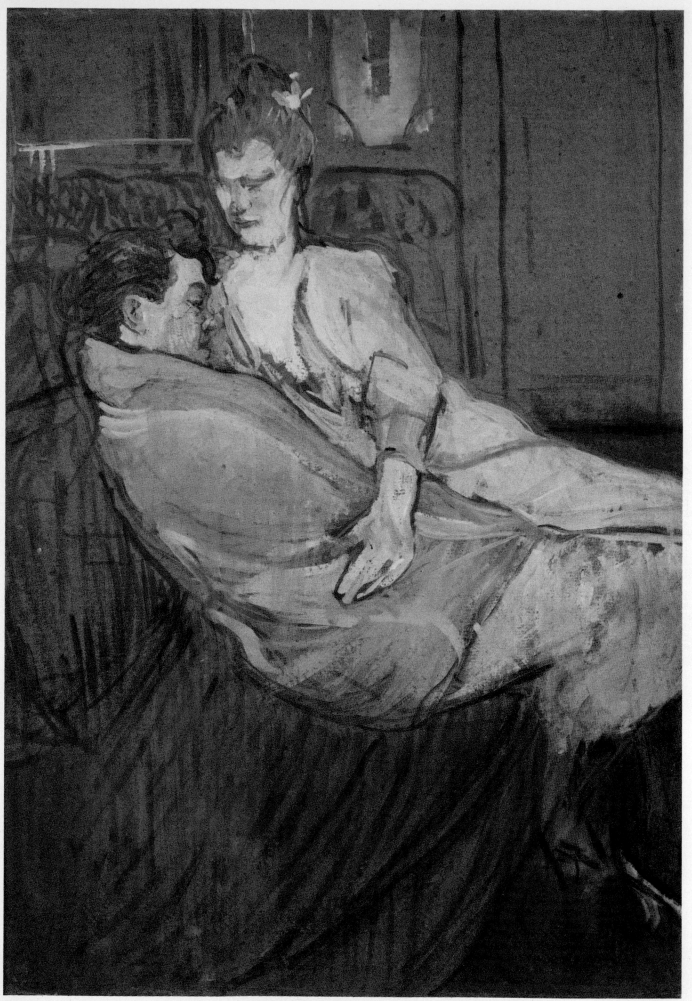

26. *Les Deux Amies. c.* 1894. London, Tate Gallery

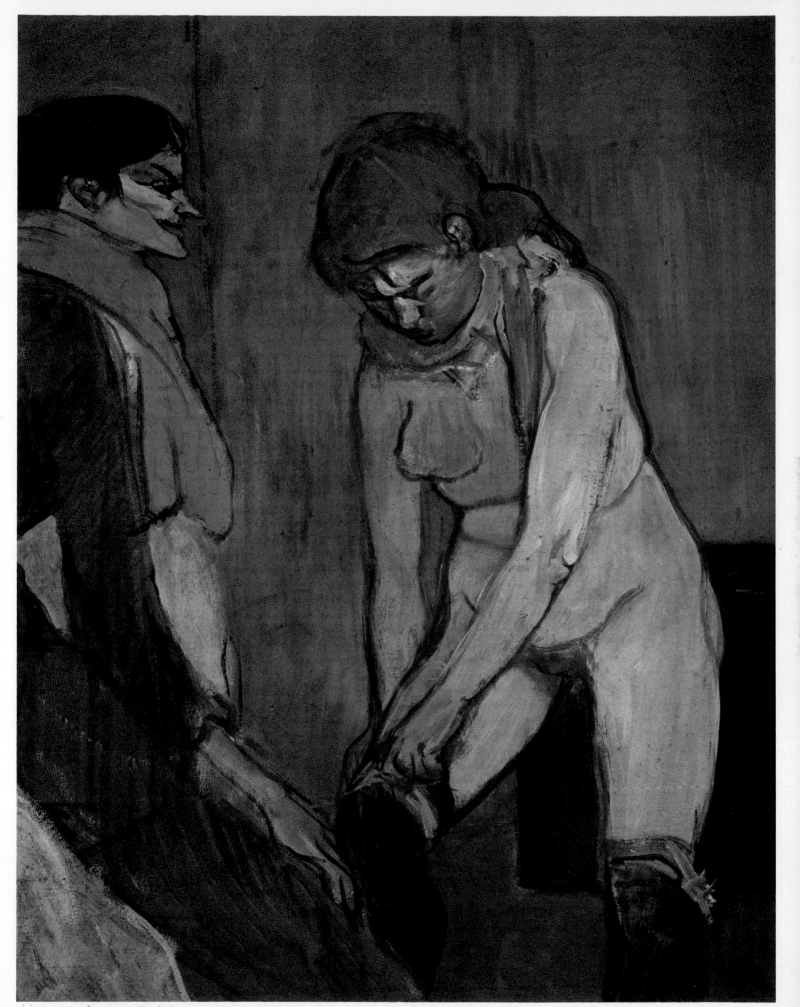

27. *Woman Adjusting her garter*. 1894. Paris, Louvre (Jeu de Paume)

28. *Loie Fuller*. 1893. Paris, Bibliothéque Nationale

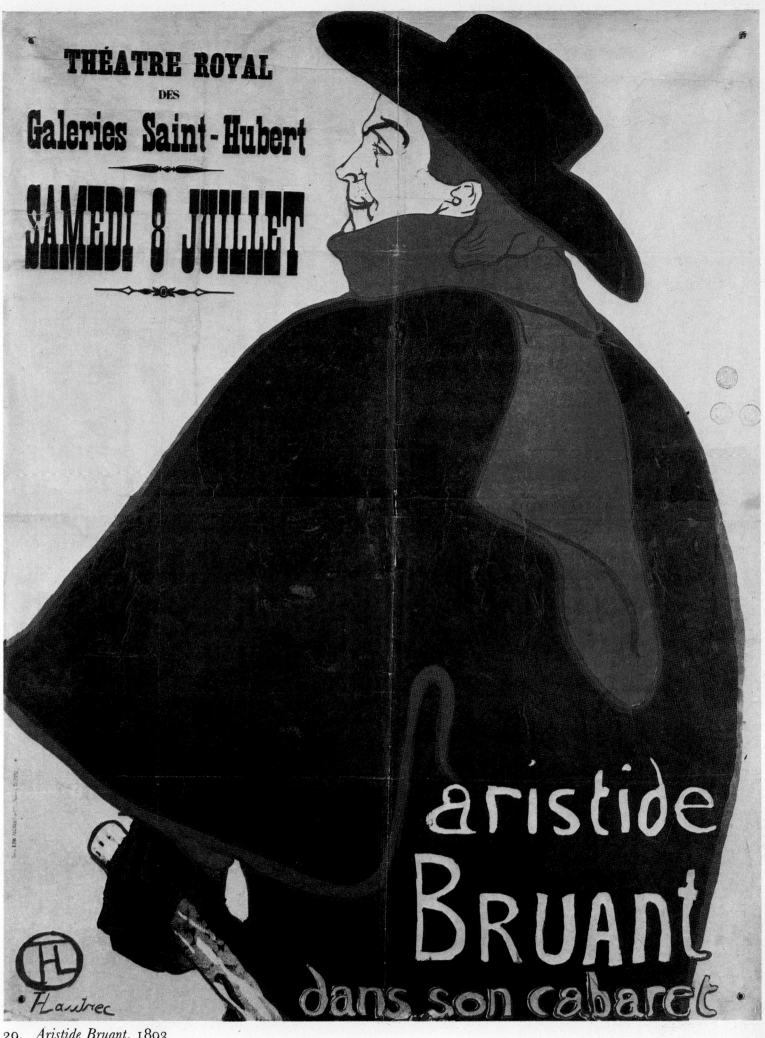

29. *Aristide Bruant.* 1893

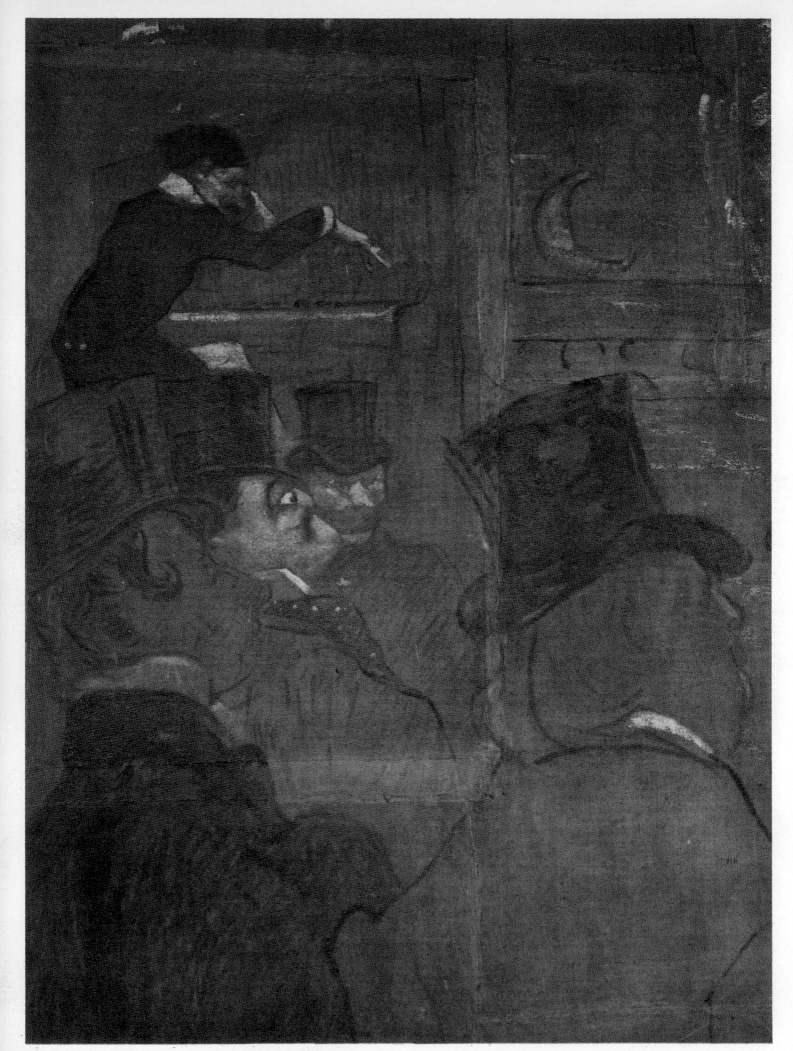

30. Detail of Plate 33, showing Oscar Wilde

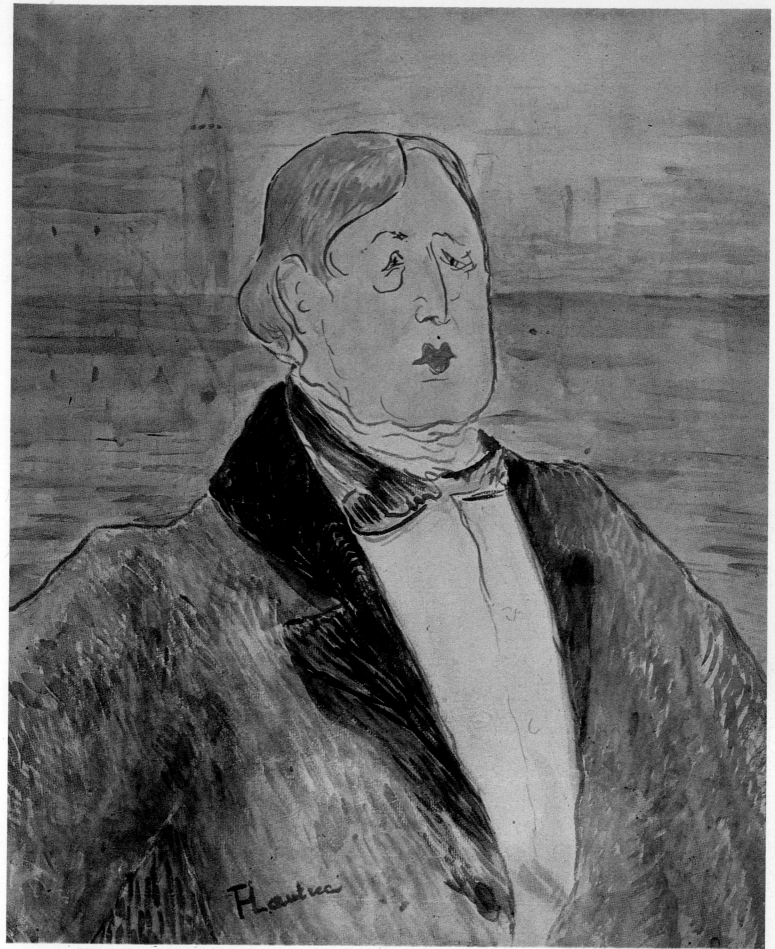

31. *Oscar Wilde.* 1895. Beverley Hills, California, Lester Collection

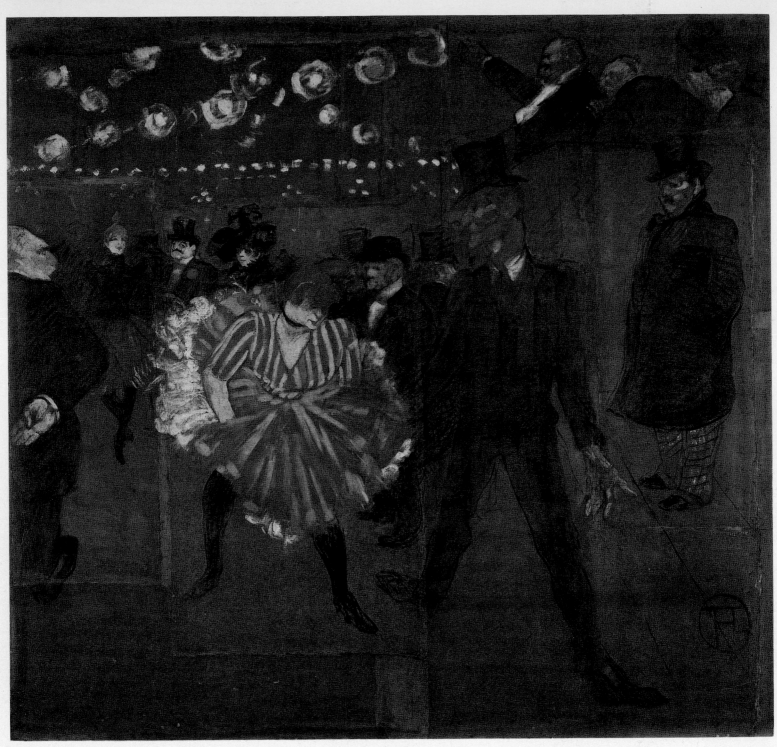

32. *La Goulue Dancing with Valentin le Désossé.* 1895. Paris, Louvre

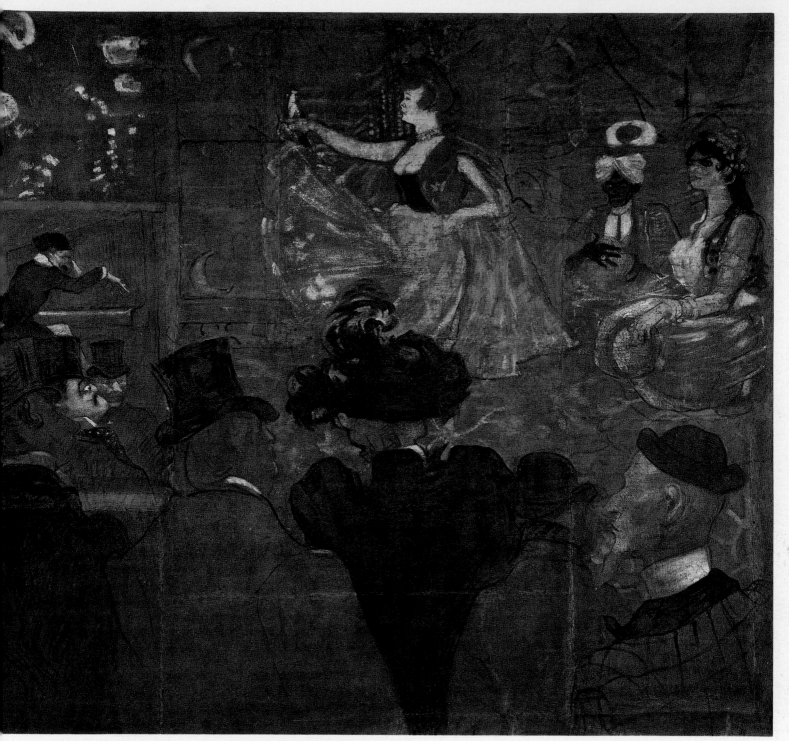

La Goulue Dancing ('La danse de l'Almée'). 1895. Paris, Louvre

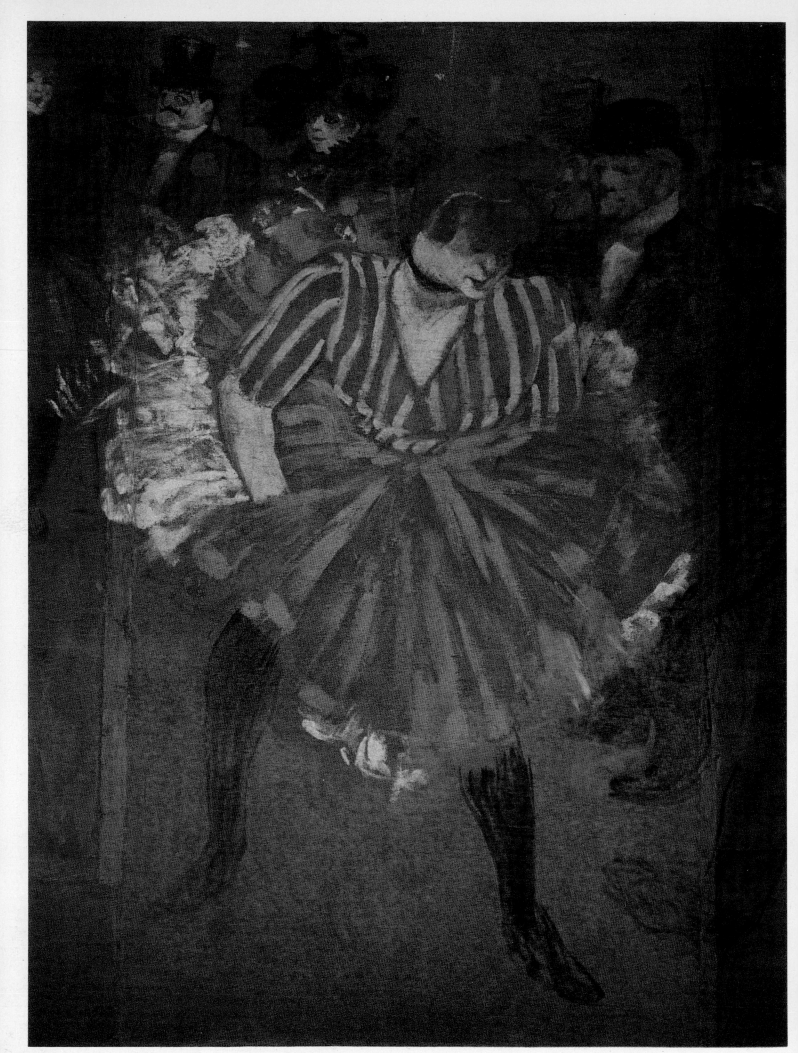

34. Detail of Plate 32

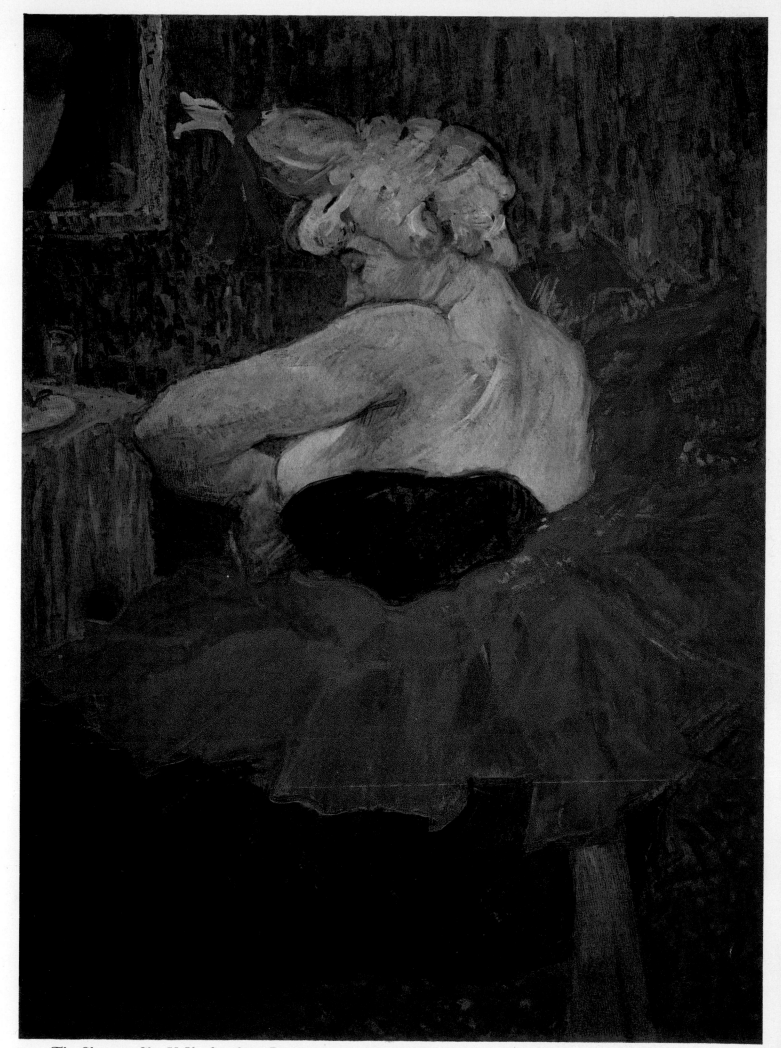

35. *The Clowness Cha-U-Ka-O.* 1895. Paris, Louvre (Jeu de Paume)

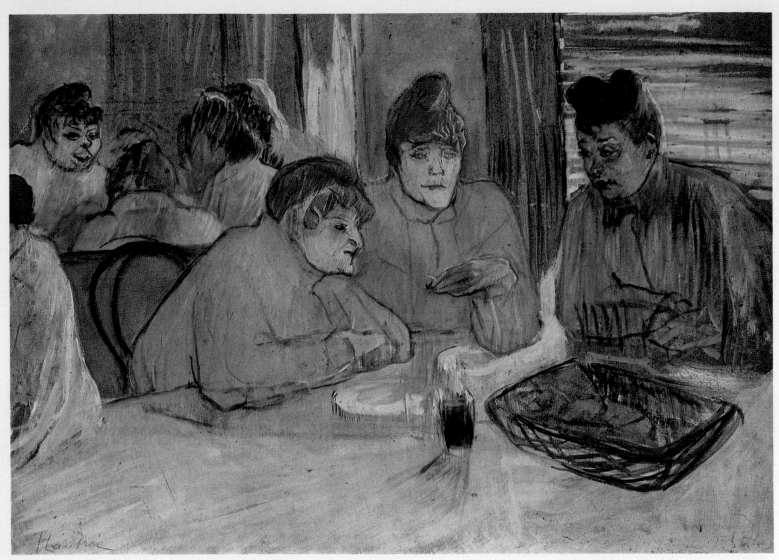

36. *Women in a Brothel*. 1896. Paris, Louvre

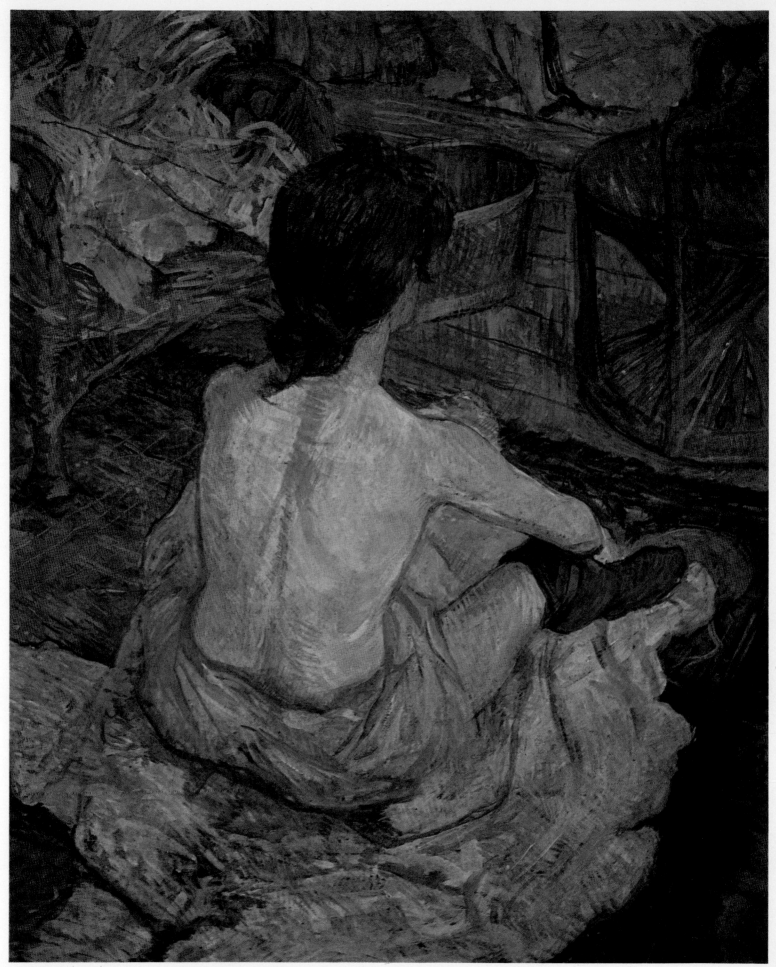

37. *Woman at her Toilet*. 1896. Paris, Louvre

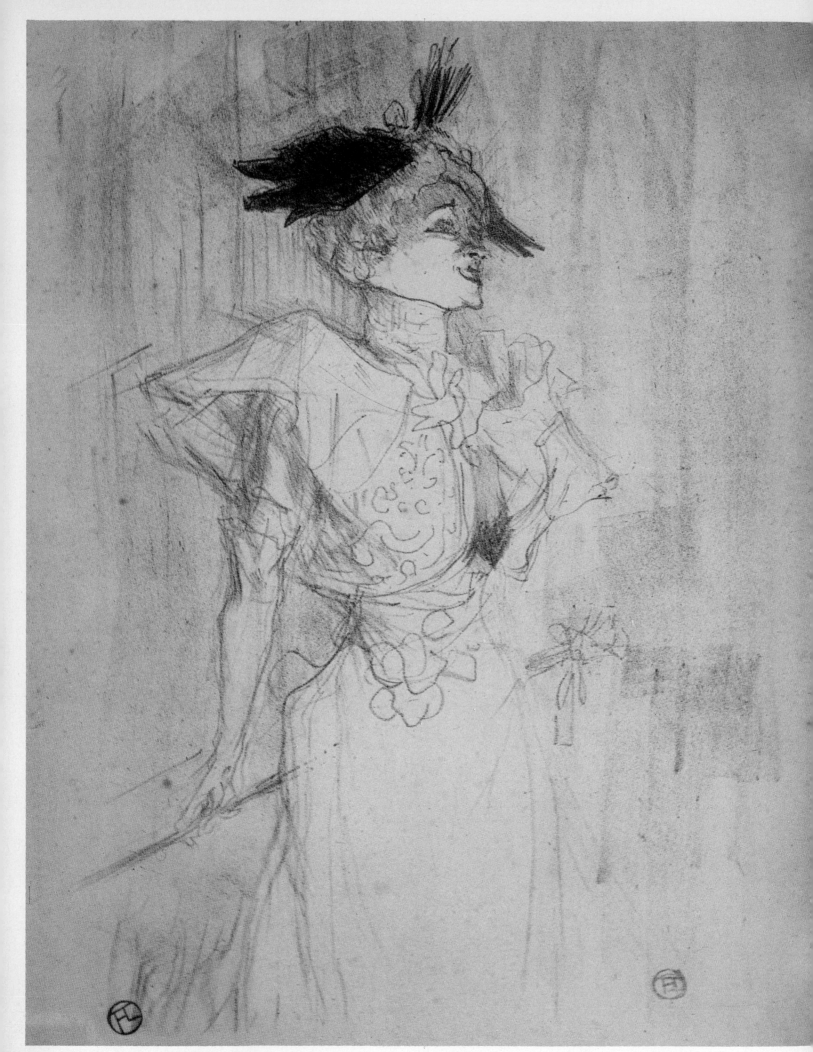

38. *Marcelle Lender, Standing.* 1896

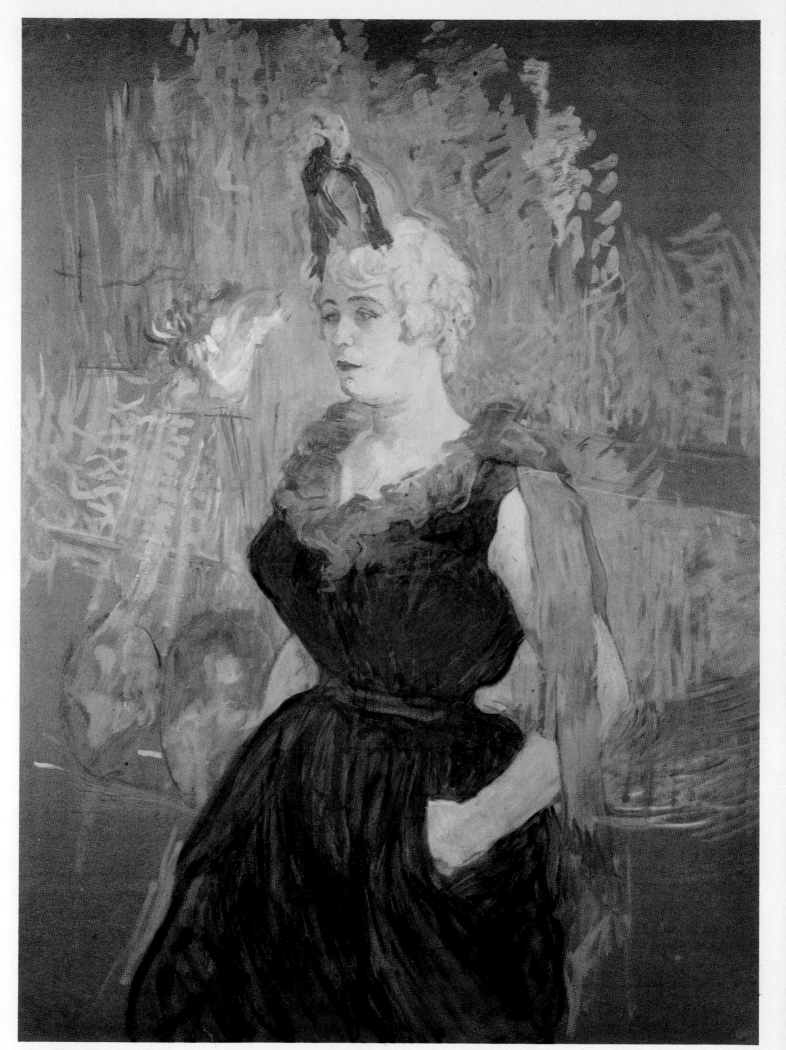

39. *The Clowness Cha-U-Ka-O.* 1895. New York, Mrs Florence Gould Collection

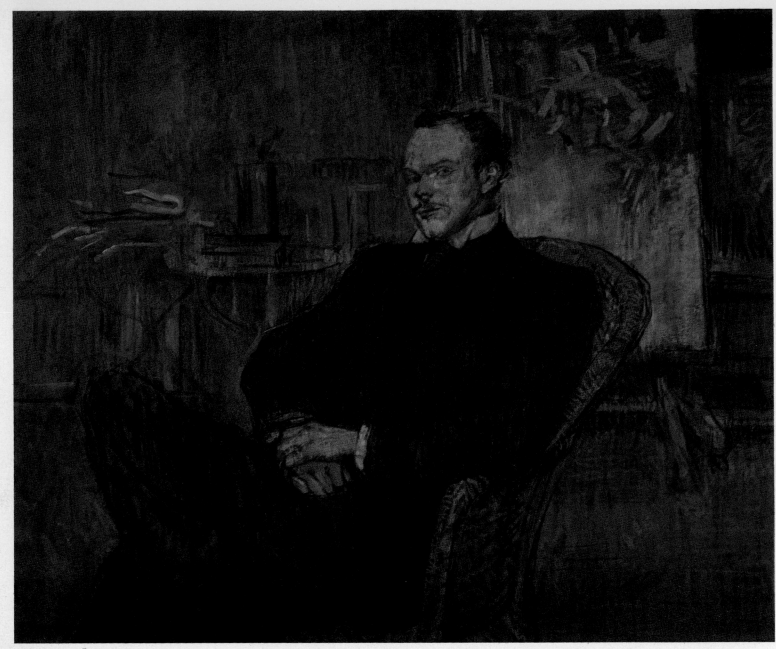

40. *Paul Leclerq.* 1897. Paris, Louvre (Jeu de Paume)

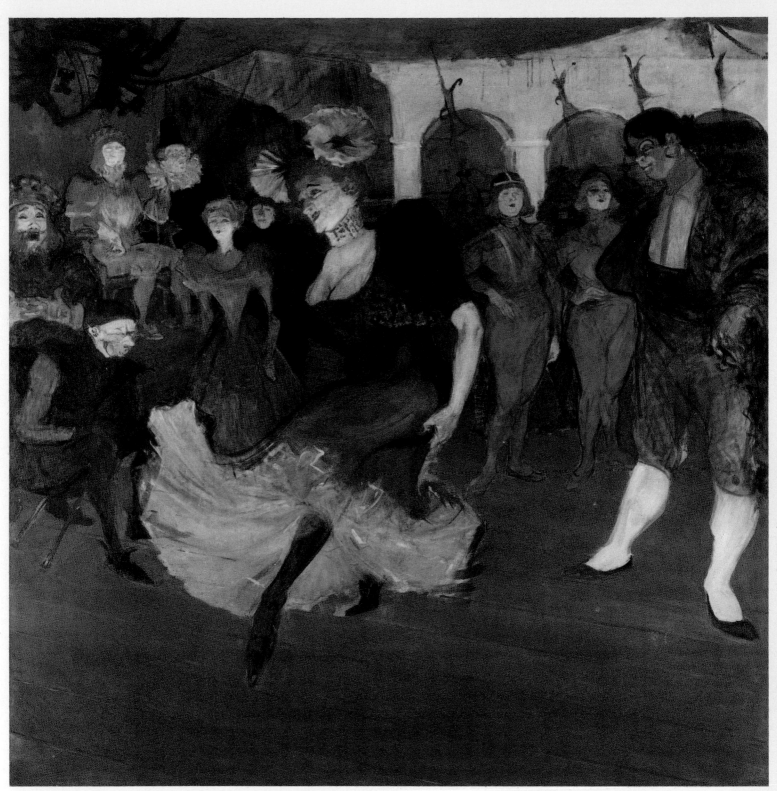

41. *Marcelle Lender Dancing the Bolero in 'Chilperic'*. 1895. New York, John H. Whitney Collection

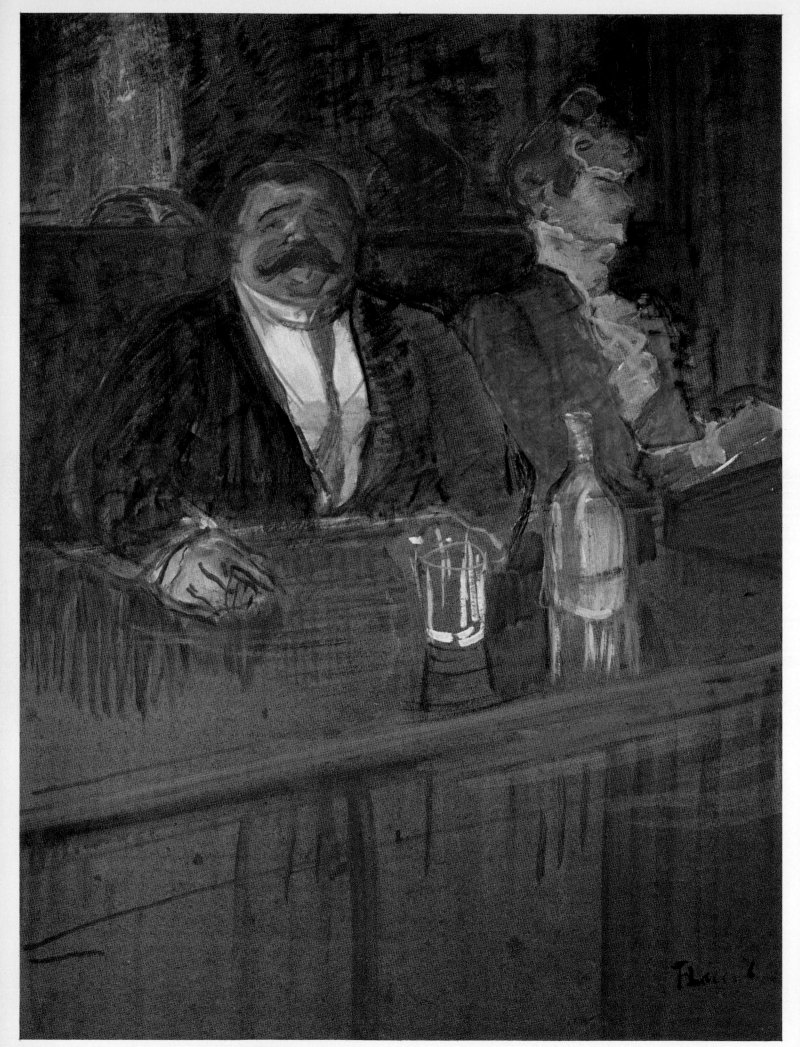

42. *In the Bar.* 1898. Zürich, Kunsthaus

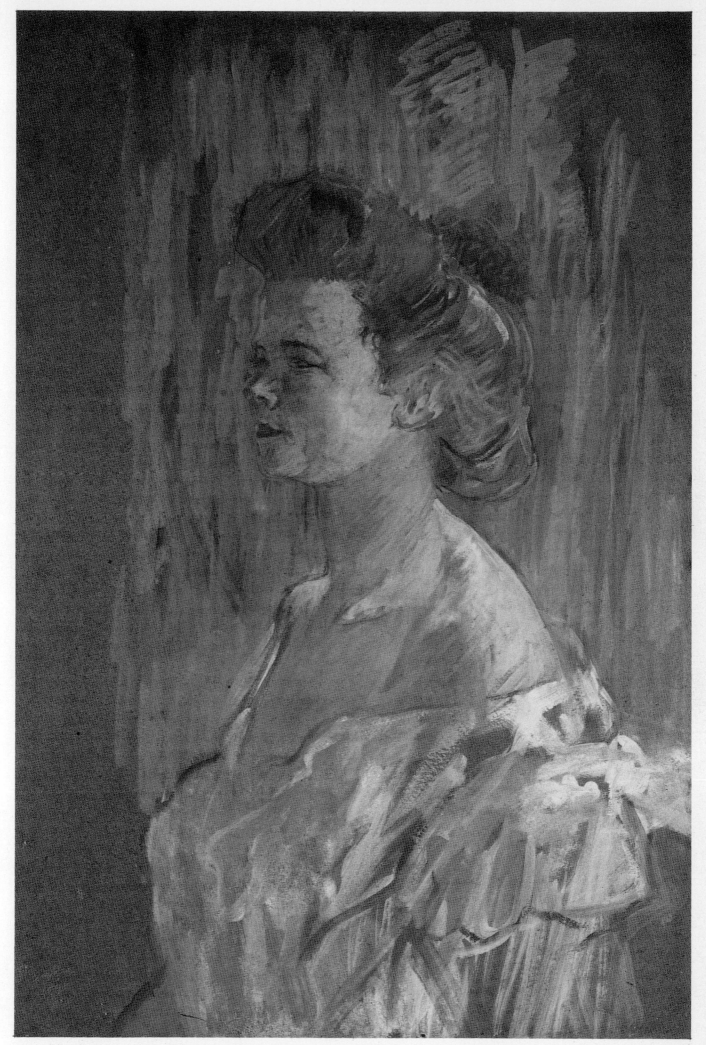

43. *The Sphinx*. 1898. Zürich, Alfred Haussmann Collection

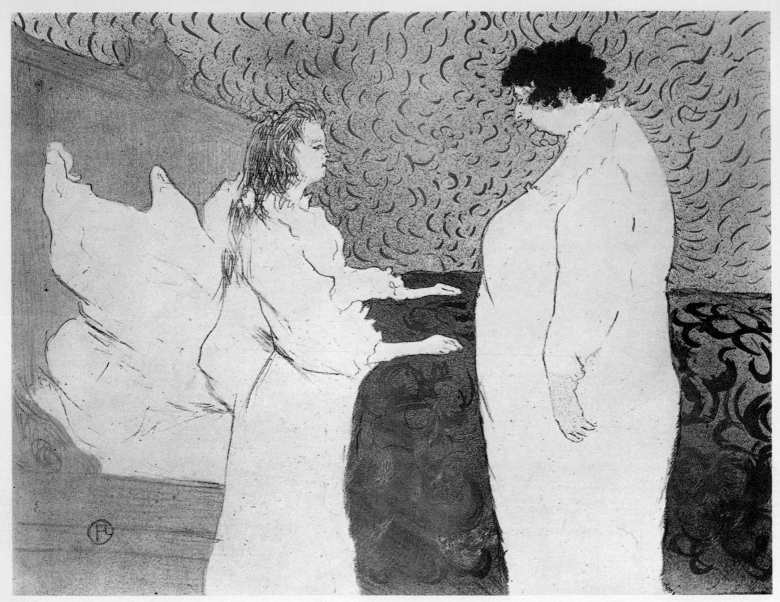

44. '*Au Petit Lever*'. 1896

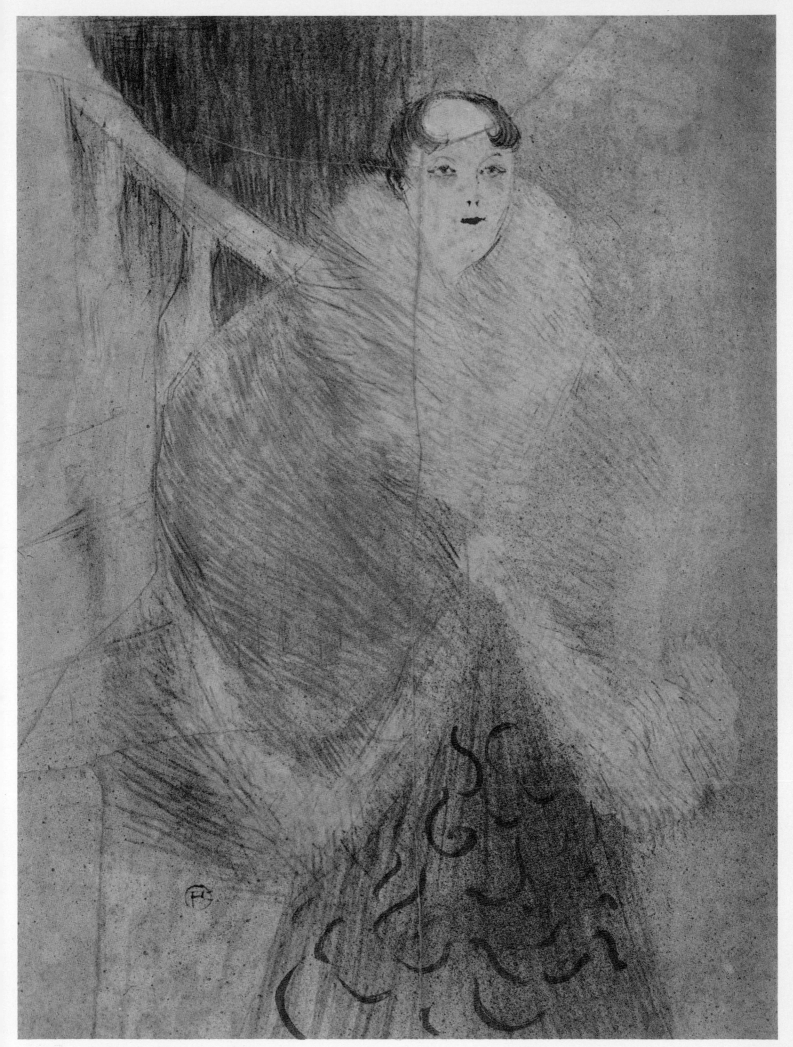

45. *Elsa, Called 'La Viennoise'*. 1897

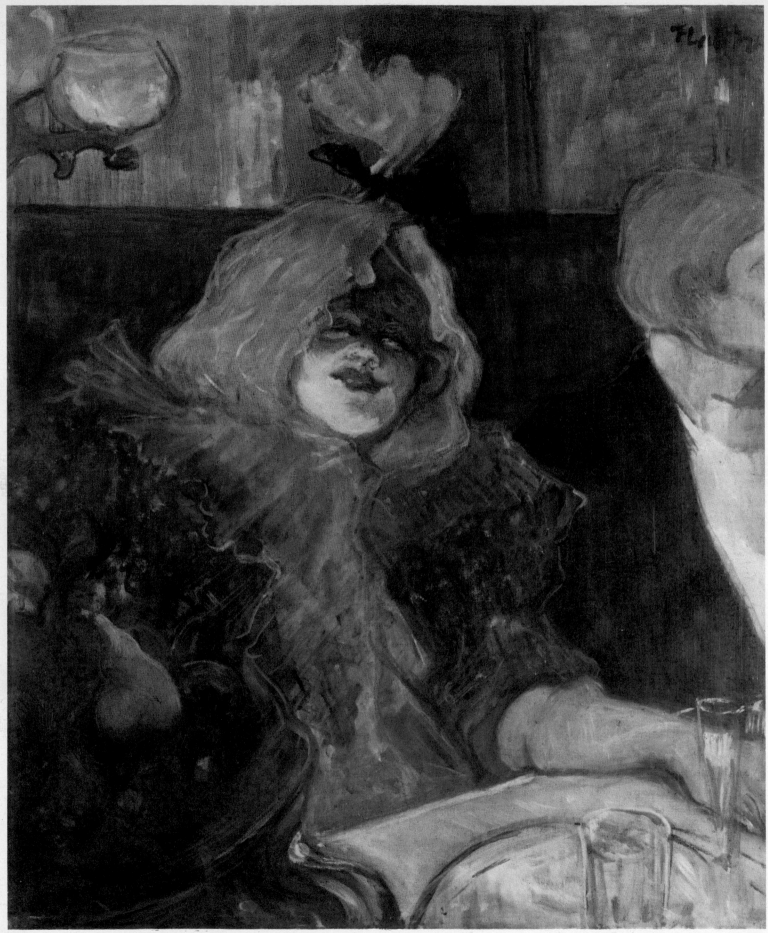

46. *Tête-à-tête Supper*. 1895. London, Courtauld Institute Galleries

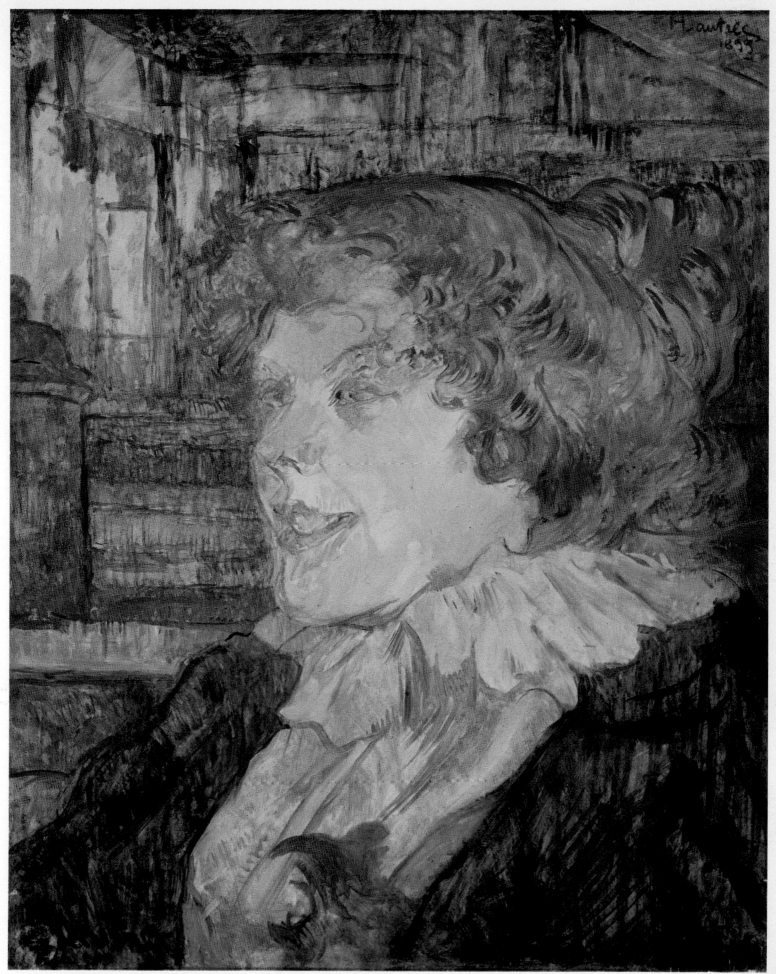

47. *The English Girl from the 'Star' at Le Havre.* 1899. Albi, Toulouse-Lautrec Museum

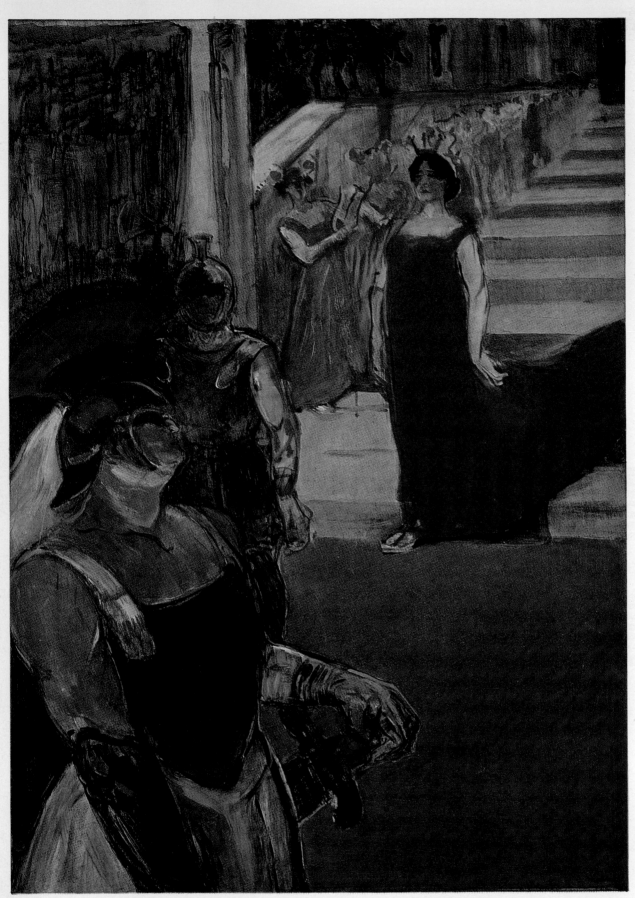

48. *Scene from 'Messaline' at the Bordeaux Opera.* 1900–1. Los Angeles, County Museum